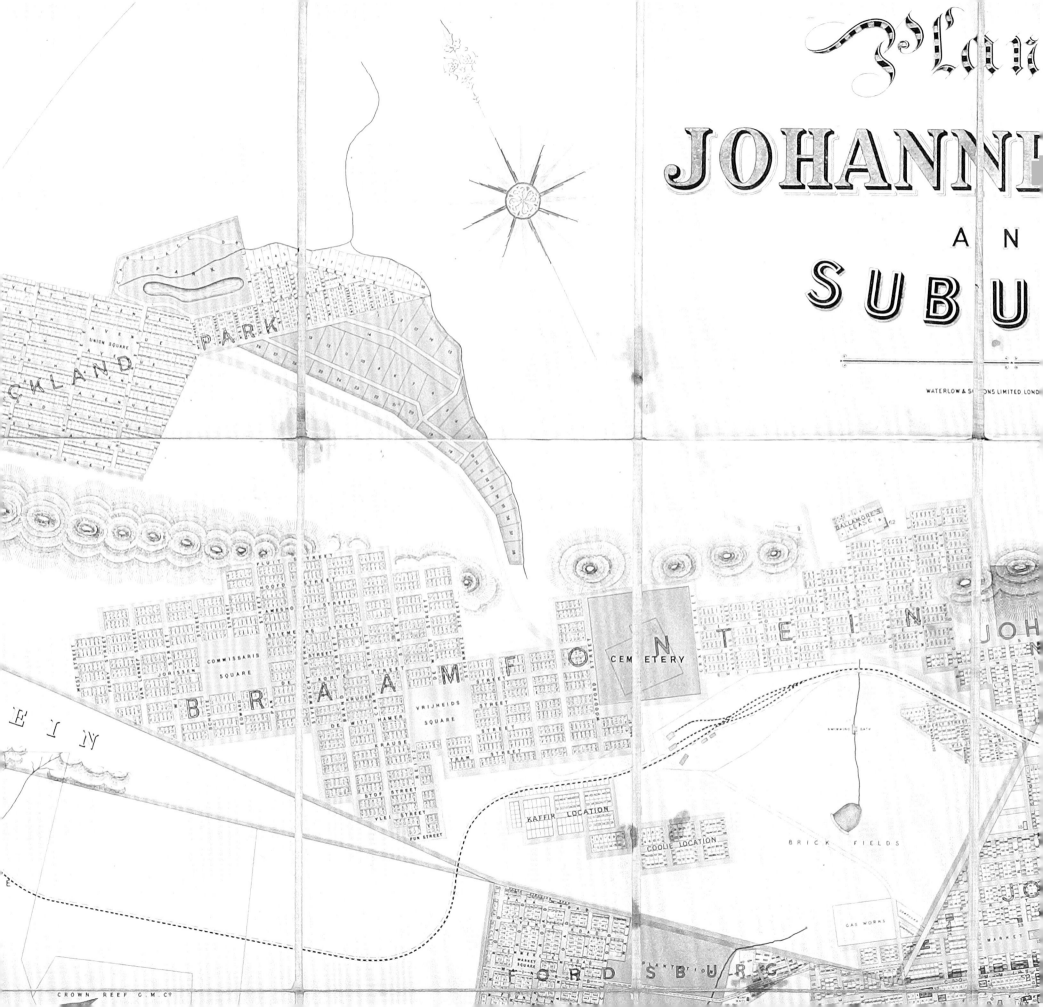

Plan

JOHANN[ESBURG]

AN[D]

SUBU[RBS]

WATERLOW & SONS LIMITED LOND[ON]

UNION SQUARE

[O]CKLAND PARK

BRAAMFONTEIN

CEMETERY

COMMISSARIS SQUARE

VRIJHEIDS SQUARE

JOH[ANNESBURG]

[F]EIN

KAFFIR LOCATION

COOLIE LOCATION

BRICK FIELDS

SWIMMING BATH

GAS WORKS

MARKET SQUARE

[F]ORD'SBURG

JO[HANNESBURG]

CROWN REEF G.M. Cº

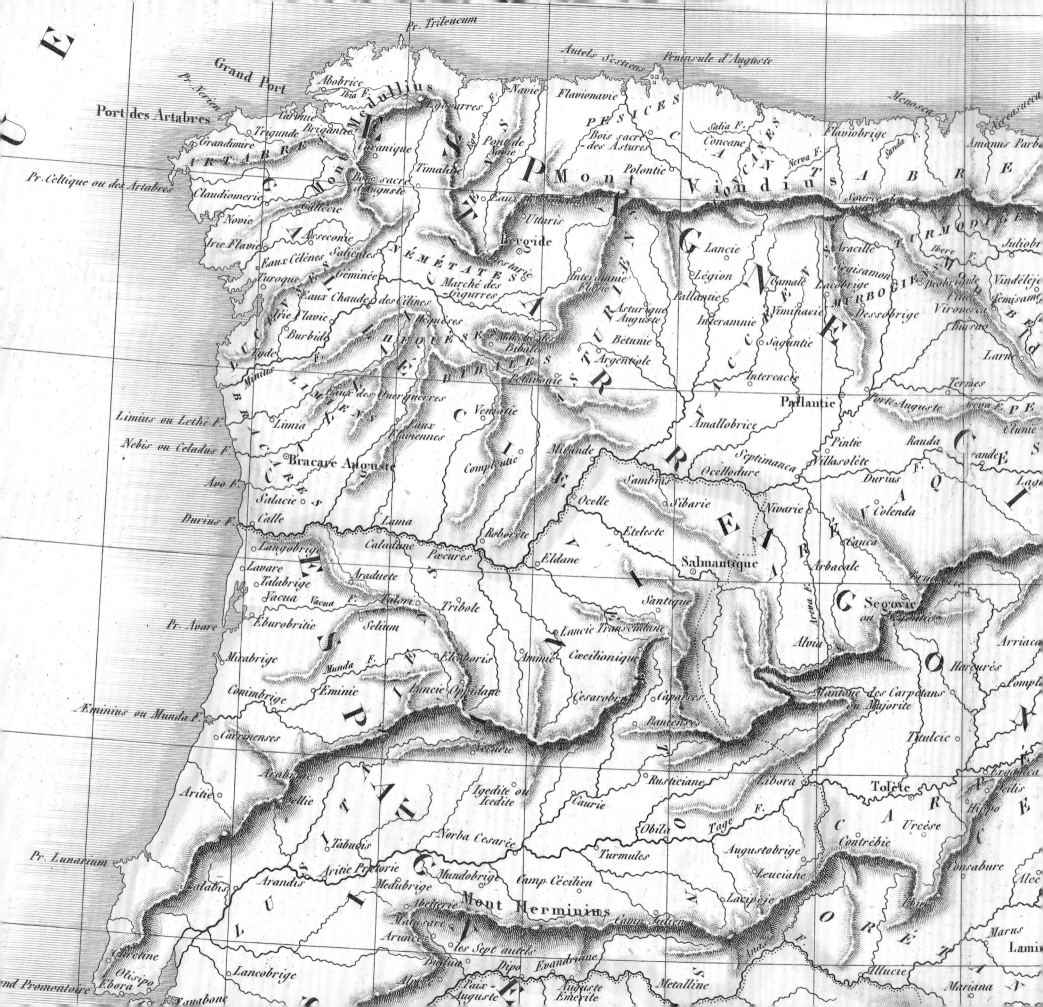

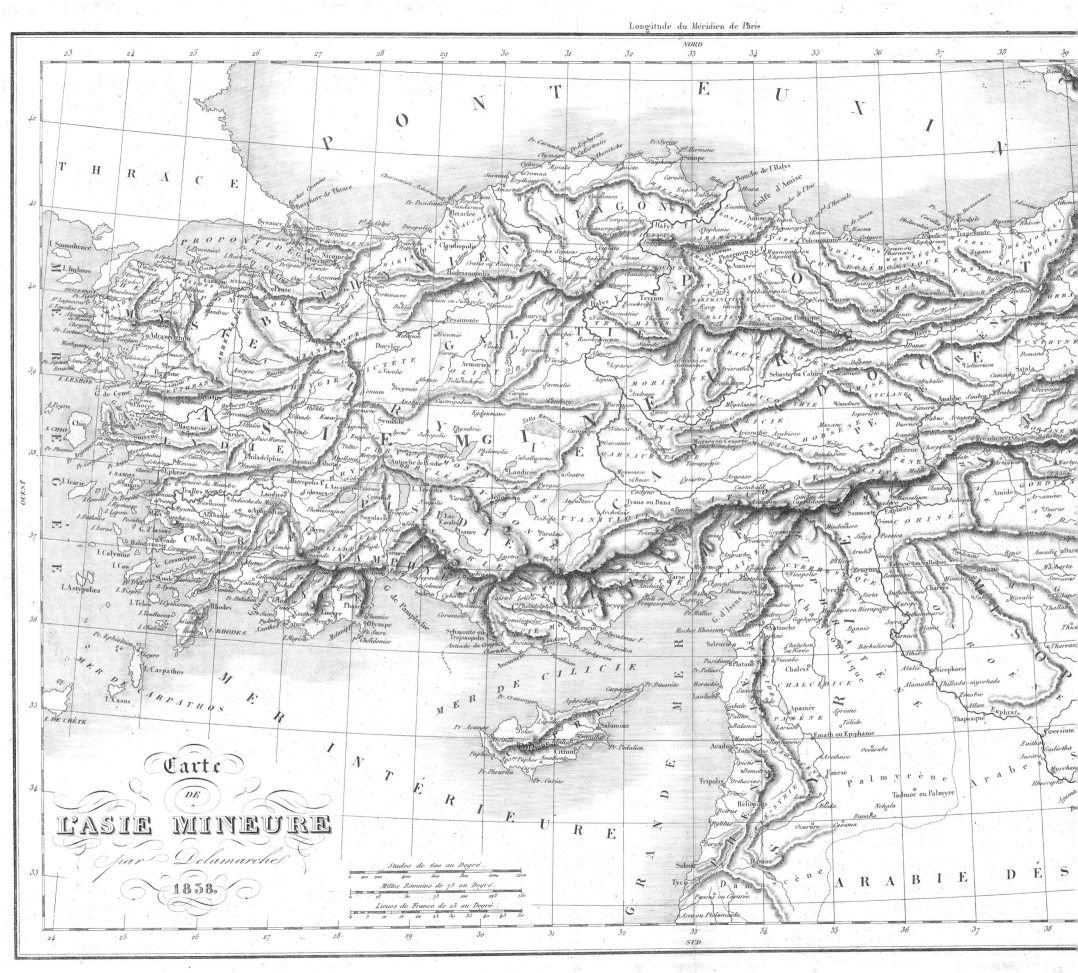

Carte
DE
L'ASIE MINEURE
par Delamarche
1838.

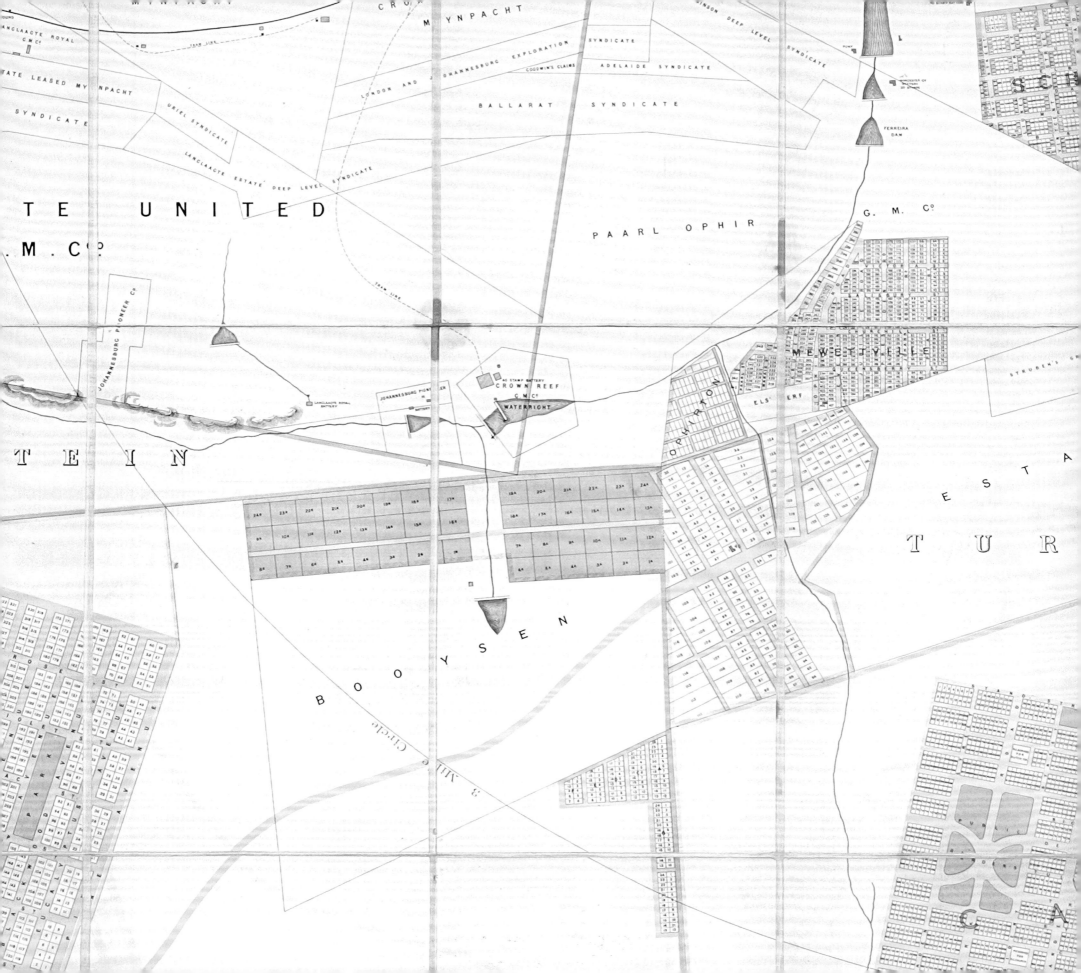

WILLIAM KENTRIDGE TAPESTRIES

EDITED BY

Carlos Basualdo

WITH ESSAYS BY

Gabriele Guercio, Okwui Enwezor,
and Ivan Vladislavić

Philadelphia Museum of Art
in association with
Yale University Press
NEW HAVEN AND LONDON

This book is published on the occasion of the exhibition *William Kentridge: Tapestries* at the Philadelphia Museum of Art, December 12, 2007, to April 6, 2008.

Support for this exhibition was provided by the Philadelphia Exhibitions Initiative, a program of the Philadelphia Center for Arts and Heritage, funded by The Pew Charitable Trusts, and administered by The University of the Arts. Additional funding was provided by a generous gift from Dina and Jerry Wind.

Front cover: Details from (*left to right*) map of Asia Minor by Félix Delamarche, in *Atlas de la géographie ancienne, du moyen âge, et moderne, adopté par le conseil royal de l'instruction publique* (Paris: Delamarche, 1838); William Kentridge, *Puppet Drawing* (plate 13); Kentridge, *Porter Series: Asie Mineure (Tree Man)* (plate 25)

Back cover: Photograph by John Hodgkiss. Courtesy of the William Kentridge Studio, Johannesburg

Pages 1, 4–5: Details from *Plan of Johannesburg and Suburbs*, 1890. Courtesy of the William Kentridge Studio, Johannesburg
Pages 2–3: Details from maps in Delamarche, *Atlas de la géographie ancienne*

All tapestry production photographs by John Hodgkiss. Courtesy of the William Kentridge Studio, Johannesburg

Published by the Philadelphia Museum of Art in association with Yale University Press, New Haven and London

Yale University Press
302 Temple Street
P.O. Box 209040
New Haven, CT 06520-9040
www.yalebooks.com

Edited by David Updike
Production by Richard Bonk
Designed by Katy Homans
Printed and bound in Canada by Transcontinental Litho Acme, Montreal

Library of Congress Cataloging-in-Publication Data

Kentridge, William, 1955–
 William Kentridge : tapestries / edited by Carlos Basualdo ; with essays by Gabriele Guercio, Okwui Enwezor, and Ivan Vladislavić.
 p. cm.
 Catalog of an exhibition at the Philadelphia Museum of Art, Dec. 12, 2007–Apr. 6, 2008.
 ISBN 978-0-87633-256-6 (PMA hardcover : alk. paper) —
ISBN 978-0-300-12686-0 (Yale hardcover : alk. paper)
 1. Kentridge, William, 1955– —Exhibitions. 2. Tapestry—South Africa—History—21st century—Exhibitions. I. Basualdo, Carlos, 1964– II. Philadelphia Museum of Art. III. Title. IV. Title: Tapestries.
 NK3089.8.S62K462 2008
 741.968—dc22 2007043104

Contents

Lenders to the Exhibition

Melva Bucksbaum and Raymond Learsy, Connecticut

Edwin C. Cohen, New York

Isabel and Agustín Coppel, Mexico City

Massimo d'Alessandro, Rome

D'Amato Collection, Naples

Johannesburg Stock Exchange, South Africa

Leo and Pearl-Lynn Katz, Bogotá, Colombia

William Kentridge, Johannesburg

The Museum of Modern Art, New York

Anne and William Palmer, New York

Brenda Potter and Michael Sandler, Beverly Hills, California

Lia Rumma Gallery, Milan

Dr. and Mrs. Jerry Sherman, Baltimore

Marc and Livia Straus Family Collection

Bette Ziegler, New York

and anonymous lenders

Foreword

The Philadelphia Museum of Art is honored and delighted to present the first exhibition in the United States of William Kentridge's extraordinary tapestries, together with a selection of related collages, sculptures, and etchings that suggest the visual and poetic thought processes informing all of Kentridge's art. So tightly "woven" together, yet so open-ended in their sources and dramatic in their effect, his tapestries, too, prove cinematic despite their large scale and apparently fixed role as wall coverings. (That the same might be said of tapestries from earlier centuries can be felicitously seen in this Museum, where the celebrated Constantine tapestries, designed by Peter Paul Rubens and Pietro da Cortona, unroll their powerful imagery around the Great Stair Hall.)

Since his arrival at the Museum to take up the new position of Curator of Contemporary Art in September 2005, Carlos Basualdo has proved a master of subtle innovation, creating beautiful and thought-provoking installations within the increasingly tight constraints of the Museum's existing space for our growing contemporary collections. This exhibition is the fourth in a series he has named *Notations*, after John Cage's marvelous book of musical scores contributed by artists and composers, and the first to be accompanied by a catalogue, thanks to the generosity of Museum Trustee Jerry Wind and his wife, Dina. Their contribution supported all aspects of this project, from the production of this beautiful book to the planning of the exhibition. Their ongoing commitment to the series of public programs called Art and Social Transformation also enables the Museum to invite artists and writers in conjunction with its exhibitions to engage the public in discussions revolving around the social and political dimensions of art-making—concerns that lie at the heart of Kentridge's practice.

William Kentridge: Tapestries would not have been possible without a generous grant from the Philadelphia Exhibitions Initiative, and once again we thank its director, Paula Marincola, for her exceptional support in bringing important new work to Philadelphia. We are profoundly grateful to the lenders who have generously agreed to part with these extraordinary works, allowing them to be exhibited together for the first time. Finally, we warmly thank the members of the Committee on Modern and Contemporary Art, whose generosity supported the acquisition of Kentridge's spectacular tapestry *Office Love* for the Museum's expanding collection of the art of our time.

ANNE D'HARNONCOURT
The George D. Widener Director and Chief Executive Officer

Acknowledgments

As the most ambitious iteration of *Notations* to date, *William Kentridge: Tapestries* required complex coordination, gracious cooperation, and crucial support from a wide spectrum of people in order to locate, borrow, exhibit, and publish works by Kentridge from collections throughout the world. The three galleries that represent the artist are devoted proponents of his work and have obliged us with help in the essential logistics of exhibition-making. First and foremost, Lia Rumma must be commended for her support and dedication to this project; in fact, the inspiration for the show found its source in her passionate commitment to Kentridge's art and to his tapestries in particular. Also at Lia Rumma Gallery in Milan, Paola Potenta and Sofia Bocca helped coordinate the tapestry loans. At Marian Goodman Gallery in New York, Rose Lord and Andrew Richards were instrumental in contacting the lenders of Kentridge's *Puppet Drawings*. Linda Givon and Kirsty Wesson at Goodman Gallery in Johannesburg have supported the exhibition and gone to notable lengths to aid us in securing loans. Darsie Alexander at the Baltimore Museum of Art was also extremely helpful in contacting lenders.

Throughout all stages of planning this project, William Kentridge has been characteristically generous as he shared the wonder of the world he conjures in this exhibition. His studio assistant, Anne McIlleron, was most helpful as she continually fielded our many requests, supplied images, and verified information. Kentridge's photographer, John Hodgkiss, has captured the making of the tapestries in vivid detail, and we thank him for sharing his photographic documentation in the catalogue. We also thank Gregor Jenkin, who designed and constructed the inventive tables on which Kentridge's bronze sculptures and *Portage* book are exhibited. Marguerite Stephens, director of the Stephens Tapestry Studio in Johannesburg, has been an invaluable resource throughout this project, providing firsthand accounts of the elaborate process by which the tapestries were made.

Many staff members at the Philadelphia Museum of Art contributed their expertise and enthusiasm to this exhibition. The intricacies of the world of tapestry were made comprehensible to us by Sara Reiter, Conservator of Costume and Textiles, who shared her knowledge of weaving and dedicated much time to aid in the handling and photographing of the tapestries. Suzanne Wells and Zoe Kahr in the Department of Special Exhibitions provided key organizational support by coordinating the efforts of all Museum departments involved in exhibition planning and preparation. Senior Registrar Irene Taurins and Assistant Registrar Wynne Kettell worked tirelessly, strategically, and effectively to bring the works to the Museum. Jack Schlechter and Kate Higgins must be recognized for their innovative installation design. Gary Hiatt of the Department of Prints, Drawings, and Photographs was enormously helpful in reframing drawings and building the platform for Kentridge's *Portage* book. Andrea Simon and Graydon Wood brought their talents to photographing the tapestries. Eleonora Charans initiated contacts and commenced research in the early stages of the project and helped with logistics throughout its realization. In the Department of Modern and Contemporary Art, Emily Hage gave initial support and assistance for the project, and Lauren Bergman provided continuous support. Erica Battle assisted Carlos Basualdo in all

curatorial and editorial aspects of both the exhibition and its accompanying catalogue, coordinating all the participants involved.

We thank the Museum's Publishing Department for producing an exceptional catalogue that both celebrates and critically examines Kentridge's tapestries and related works. Sherry Babbitt oversaw the entire process with her distinctive attention to detail. We are also indebted to David Updike for his vision and determination in all stages of catalogue production, Rich Bonk for his precision in ensuring the quality of its printing, and Katy Homans for her originality in creating the elegant design.

Finally, we would like to thank the three authors who have contributed stimulating and informative essays to this catalogue. Gabriele Guercio, a critic and art historian who recently published *Art as Existence: The Artist's Monograph and Its Project*, provides an account of the fluctuating history of tapestry in Western art and elucidates Kentridge's unique engagement with the medium. Okwui Enwezor, Vice President and Dean of Academic Affairs at the San Francisco Art Institute—and also the artistic director of the second *Johannesburg Biennial* of 1997 and *Documenta 11*, both of which featured Kentridge's work—positions the tapestries both within the horizon of the artist's oeuvre and in relation to the South African landscape. Ivan Vladislavić, who has written incisively about daily life in Johannesburg in books such as *Portrait with Keys*, weaves art, literature, and personal experience into an account of the changing topography of South Africa. Their thought-provoking essays gracefully guide us through reading, interpreting, and considering this new body of work by Kentridge.

Permanent Projections

CARLOS BASUALDO

OFFICE LOVE

The city whose precisely drafted plan can be seen in the background of William Kentridge's tapestry *Office Love* (plate 17) did not exist as such in 1890, when the map was initially drawn. It was, to a large degree, a pure invention that would only start to be realized four years later, as a somewhat unintended effect of the Witwatersrand Gold Rush that had begun in 1886. The physiognomy of Johannesburg would then hurriedly begin to change, with streets busily emerging from existing farmland, and the real city would only then start to resemble its imagined, utopian counterpart found in the map. As the South African writer Ivan Vladislavić beautifully narrates in his essay in this catalogue, wheat fields would eventually give way to booming banks, to busy hotels, and to the noisy rumble of the unfolding streets of Johannesburg. The background of *Office Love* is nothing but a shadow that ended up projecting its own reality, so that the 1890 map, which Kentridge tore to pieces and then partially and seamlessly reassembled, inevitably functions as a metaphor for the complex relationship between fact and fiction from which his work vigorously stems. Tangible facts and sheer imagination coexist in his practice as reflections of the changing facets of human experience. In his work, it is not the object that projects its shadow, but the shadow that imagines the object and projects it into our consciousness, shaping it.

Nothing but tangible shadows, then, drive the protagonists of so many of Kentridge's films, drawings, and sculptures. And clearly shadows are the main characters of the dubious drama suggested by the richly textured figures that confront one another on the carefully woven surface of the Johannesburg map in *Office Love*. First we see what appears to be a strong-legged man in a suit stepping firmly across the scene, his bulging torso crowned by an old typewriter. A diminutive office chair stands in his way, as if timidly springing to his rescue. The man himself is almost dwarfed by a very tall and narrow desk that, like the city, has finally grown out of proportion. It is ominously adorned with a pair of hanging scissors and protruding drawers and topped by an oversized ink blotter that overlooks him. The typewriter-man is an unwilling bull, perhaps ignoring the double sword of the scissors that seems destined for him. He is a writer eternally afraid of his task, waiting to be seduced and annihilated by the threatening, mantis-like desk. Caught by his passions, he does not seem afraid to confront them, but it is to no avail, as the sprawling imaginary city engulfs both him and the object of his attention. As in many other works by Kentridge, an inner world of turbulent and partially hidden emotions is shattered when the larger world of brutal facts enters the picture. The typewriter-man, even if he does not yet know it, is literally made of the same stuff as the city—both are torn and recomposed figures, conjured from a mixture of wool, labor, and desire. He may remind the viewer of one of Kentridge's earlier characters, certainly of the melancholic Felix Teitlebaum in the earliest of his nine *Drawings for Projection* (1989–2003), but he is also Zeno from the film *Zeno Writing* (2002), a sensitive character fully enmeshed in his personal passions, which are secretly destined to be interrupted by the tragic outbreak of a war. Characters and situations tend to reappear throughout Kentridge's

Opposite and following pages: William Kentridge, details from *Office Love* (plate 17)

13

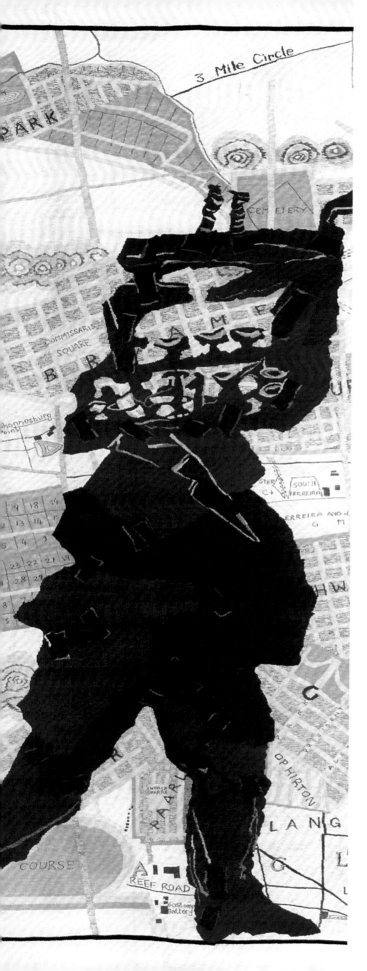

oeuvre, like permutations of recombining figures that are never quite the same but nonetheless insist on their fragile identities as resilient survivors of an unnamable wreck.

Office Love is the name of a tapestry by Kentridge, but it is also the name of a drawing that served as the point of departure for the production of the tapestry (plate 5). Amazingly, confronted with the tapestry, the first impression of the viewer may be that of seeing a very large-scale drawing, or better, a "permanent projection," as the artist describes this group of works. The tapestry is a projection because it makes us believe it is something else, an oversize drawing perhaps, or, better, another type of object that exists in between mediums, in a space of uncertainty that does not fully correspond to our preconceived ideas about the differences between drawing, projecting, and weaving.

In order for the tapestries to be made, a drawing had to be photographed, enlarged, modified and drawn upon, and then mapped onto a cartoon that would then become the source of the tapestry. This process takes approximately two months for each tapestry and is exquisitely laborious, involving at every step the collaboration of the tapestry workshop's director and weavers (twelve, at the time when this catalogue was published). First, in a Swaziland cottage, the South African mohair is carded and spun. Once the specific drawing by the artist is selected, the colors for the tapestry are chosen, and the mohair dyed by three women on the staff. The weavers then labor on the cartoon, which is itself the result of the efforts of a cartoon maker working closely with the artist. The distance between the drawings and work on the loom is mediated by a number of collective decisions, by the passage from drawing to photography and then again to drawing, and finally by the meticulous process of hand weaving (fig. 1).

Although the tapestries seem at first glance to faithfully reproduce the source drawings—and they certainly have the "look" of a drawing—a closer examination reveals the many details in which they differ. The change of scale seems to imply for Kentridge a careful and precise rethinking of other aspects of the image. Color marks are added to the uneven black surfaces of the figures and the maps; the shape of one head gains focus; and, here and there, carefully added elements—the figure of a bird, fragments of typewritten pages—appear that were absent in the drawings (fig. 2). These changes, both subtle and dramatic, become evident while comparing tapestries and drawings, as intended in this exhibition. The process is less a translation from one medium to another than a precisely calculated blurring of the possibility of conceiving of photography, drawing, and projection as separate and independent mediums. The woven image seems to unravel the image of the original drawing by entangling it with the process of its own making. The tapestry looks like a drawing that looks like a tapestry, simultaneously negating and affirming its own materiality. As the Italian art historian Gabriele Guercio eloquently lays out in his essay in this catalogue, what is so extraordinary about this group of works is that they unequivocally place drawing—and not the animated image, as is commonly believed—at the very center of Kentridge's

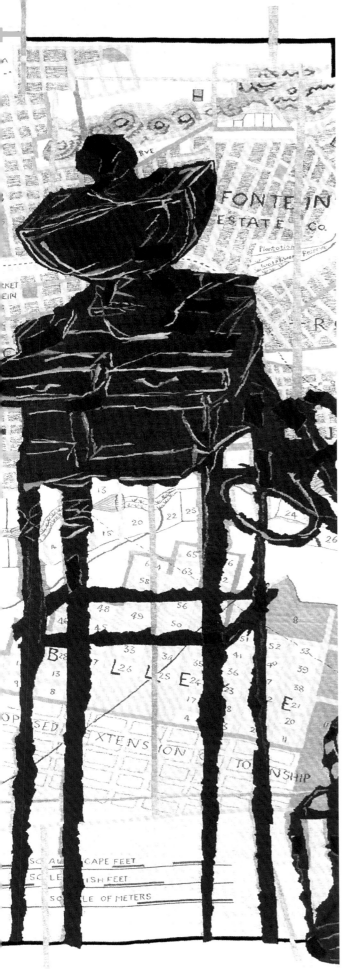

practice. Nor is it a type of drawing conceived as a privileged medium—Vasari's notion of *disegno* ideally towering over the material vicissitudes of *colorito*—but a kind of drawing used as a tool for exploring the very notion of mediality. As Guercio discusses in detail, this notion of "drawing" is almost a way of annotating, and noticing, the passage of time, one in which the graphic marks seem destined to pass while leaving traces of their passage, as if intending to reflect on the labor that was needed for their passing. This catalogue, as well as the accompanying exhibition, intends to explore, as succinctly and precisely as possible, this fundamental aspect of Kentridge's work by examining a select group of his tapestries and their corresponding drawings as well as other closely related drawings, etchings, and sculptures.

DRAWING WITH SHADOWS

The processional aspect of Kentridge's drawings is made evident in his films, where images are animated by the erasure of previously drawn marks and their replacement with new ones while still maintaining traces of the preceding images. In the series collectively titled *Puppet Drawings* from 2000 that ultimately became the source imagery for his tapestries (see plates 5–15), Kentridge replaces the precise movement of the drawn line with collages created by assembling ripped pieces of construction paper on a background of his choosing. The tearing and placement become ever more accidental as the figures are always incomplete, their jagged outlines tentative and subject to change. The figures of the *Puppet Drawings* are made of layers of torn paper, their joints articulated by metal pins that allow their constituent limbs and body parts to move, and it is from that potential for movement that they extract their dubious individuality. Concrete shadows, their contours have the imprecision of a cloud or a distant mountain range, and it is not perhaps by chance that in the film *Shadow Procession* (1999; see fig. 10) their appearance on the screen is preceded by a sequence in which we see the passing of their shadowy projections. Unlike Kentridge's drawn lines, which seemingly progress by constantly retracing themselves, the *Puppet Drawings* are in fact drawn to their immediate future, as the figures emerge through the animation and mutation activated through their potential or actual movements. They are propelled forward, in search of an elusive wholeness. The effect is that of a group of figures constantly evolving as if in a permanent state of becoming, and thus the process of drawing with shadows undoes the certainty of well-defined contours and the precision of the singular line. Unlike most of Kentridge's early films, such as *Mine* (1991) or *History of the Main Complaint* (1996), the meaning of the forms in the *Puppet Drawings* comes not from a privileged relation to their past, signaled by the erasure and redrawing of the line, but from the future as understood topologically. They signify as long as they are capable of moving—forward.

As with most of the elements in Kentridge's work, the genealogy of the images in the *Puppet Drawings* is far from linear and marvelously convoluted. The precarious puppets appear first in *Ubu Tells the Truth* (1996–97),

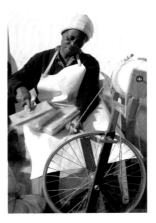

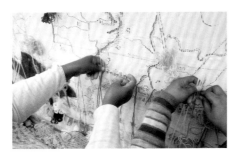

Fig. 1a–c. Kentridge tapestries in production at the Stephens Tapestry Studio in Swaziland and Johannesburg. Photographs by John Hodgkiss, courtesy of the William Kentridge Studio

Fig. 2. William Kentridge, detail from an enlarged photograph of *Puppet Drawing* with artist's marks, made in preparation for the tapestry *Porter Series: Amérique septentrionale (Bundle on Back)* (plate 21). Courtesy of the artist

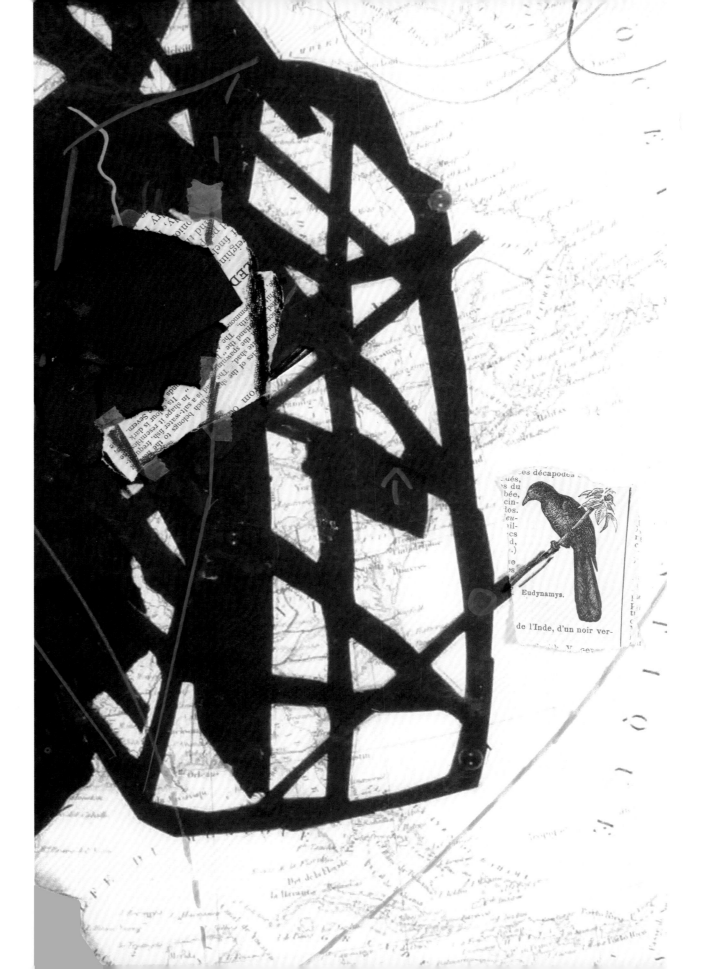

a film related to the theater production *Ubu and the Truth and Reconciliation Commission*, which Kentridge staged in 1997. There, these figures can be seen in connection with the dismembering of bodies in acts of state-sponsored violence, a relation that they will not shed. Most dramatically, they figure prominently in the films *Overvloed* (1999) and especially *Shadow Procession*, in which they appear alongside a threatening Ubu, the character from Alfred Jarry's plays, newly incarnated as a slave master. Ubu is seen again in *Procession on Anatomy of Vertebrates* (plate 1), a drawing from 2000 in which his menacing silhouette almost breaks a processional line of porters. Since then, the puppets have reappeared in many works—sculptures, films, drawings, and the tapestries—that Kentridge has produced. Almost all the characters in the tapestries and related *Puppet Drawings* included in this catalogue seem to come straight from the *Shadow Procession*, which itself is echoed in his artist book *Portage* of 2000 (plate 2). However, the contraposed figures that dominate *Office Love* seem instead related to later incarnations of the puppets, such as the characters in the films *Zeno Writing* and *7 Fragments for Georges Méliès* (2003).

As is often the case with Kentridge's work, the bronze sculptures he made around the same time as the *Puppet Drawings* seem to have been born out of the articulated paper puppets and then progressively to have acquired their identity through works such as *Procession* from 2000, *Bridge* from 2001 (plate 3), and *Promenade II* from 2002 (plate 4). The characters in *Procession* and *Bridge* resemble closely those of *Shadow Procession* and *Overvloed*, while the more complex figures of *Promenade II* first appeared in their paper incarnation as puppets in *Zeno Writing*. Interestingly, it is in the multifaceted figures of *Promenade II* that the implications of the *Puppet Drawings* are fully realized. Rotating these figures on their axes changes their silhouettes so dramatically that the different facets seem to belong to completely different figures. The stout man in a suit, for example—who will reappear as the typewriter-man of *Office Love*—suddenly turns his back to the screen to become a plumbing fixture (fig. 3). Plumbing fixtures, it has to be said, abound in Kentridge's work, their omnipresence both quotidian and potentially threatening. The identity of the individual sculptures in *Promenade II* thus depends completely upon the point of view from which one contemplates them. Evidently, it is the very identity of these characters to be in a state of transformation. Drawing, which traditionally has been associated with the possibility of representation and thus with the establishment of a fixed identity, has become, through the *Puppet Drawings* and related

Fig. 3. William Kentridge, three views of the same male figure from *Promenade II* (plate 4). Courtesy of the artist

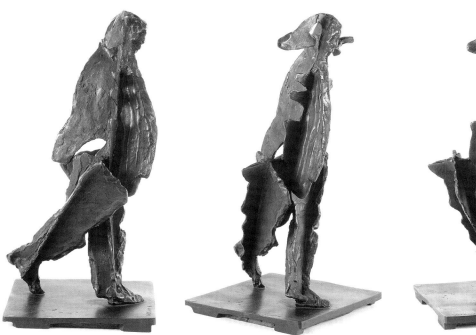

bronzes, the negation of that very possibility. Kentridge uses drawing as a tool to explore and ultimately to negate the separation between the different mediums. The process by which the sculptures came to be exemplifies that exploration, an intentional slippage from drawing to film to three-dimensional sculpture that ultimately incarnates the mutability implied in the drawings. Thus, the identity of the individual figures is no less unstable than that of the medium in which they are rendered. Typical of Kentridge's work, it was necessary for the drawings to become sculptures so that their full potential—and implications—could become tangible.

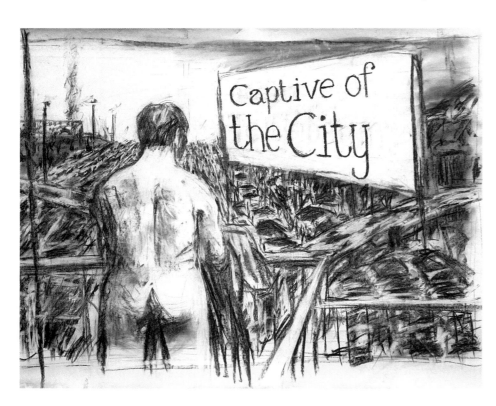

Fig. 4. William Kentridge, drawing for the film *Johannesburg, 2nd Greatest City After Paris*, 1989. Courtesy of the artist

PORTERS AND PROCESSIONS

The simultaneously weary and indefatigable figures that traverse Kentridge's *Puppet Drawings* and tapestries can be identified as stemming from two typologies that recur in his work since 1989, and that to a large degree could be said to organize and articulate the dreamlike logic of his oeuvre. The majority of the individual figures are, in fact, porters, and, although they can occasionally be seen in isolation—as in several of the tapestries and drawings—most commonly they appear spontaneously organized into groups, forming processions. In the film *Johannesburg, 2nd Greatest City After Paris* of 1989, the protagonists are both the initially deserted city and the procession that progressively occupies its desolate streets (fig. 4). Kentridge's first drawings of processions, such as *Arc/Procession I* and *Arc/Procession Study*, also date to 1989 and serve as preparations for the monumental drawing *Arc/Procession: Develop, Catch Up, Even Surpass* of 1990, where porters are intermixed with loudspeakers, a hyena, a naked woman, war amputees, and miners against a conspicuous background of shadows where these hopeless characters all seem destined to merge. There is something profoundly human and, at the same time, completely inhuman about this grouping, in which individuality is reduced to a sign of endurance and fragile subjectivities bear the traces of their undoing. The procession certainly alludes to the political climate in South Africa at the time, where the sight of human masses filled with rage and sorrow must have been a fact of everyday life, but at the same time, in the context of Kentridge's work, its appearance refers also to the profoundly tragicomic nature of human experience.

The ambiguous character of these processions is perhaps best exemplified by the 1999 film *Shadow Procession*, in which changes in the soundtrack correspond to completely different moods in the passage of the film's reluctant protagonists. An atmosphere of desolation clearly dominates, but his processions are also inevitably joyous occasions, and the broken movements of the tragic figures can suddenly become a Dionysian form of dancing. Even when reduced to sheer endurance by the weight of their loads, and while not hiding their travails

from view, the porters are profoundly affirming in their mad pursuit of the unknown, which can only come from the inextinguishable vitality of the forward movement of life itself.

Initially, in drawings like *Arc/Procession* the human figures were clearly differentiated from animals and objects. Looking at these earlier works, we can almost visualize the public demonstrations against apartheid that likely inspired them, and we can imagine a dense mass of human beings sadly parading their dignity, surrounded by the detritus of their miserable lives. In the *Puppet Drawings* and the tapestries, the figures resemble instead those that first appeared in *Ubu Tells the Truth* and then in *Shadow Procession*: they are no longer fully human but have become indistinguishable from the things that they carry. Even when the traversing figures carry nothing but themselves, they seem to have become porters. The weight of their own existence suffices. Halfway between the animate and the inanimate, they are living proof of the inexhaustible will of anything that breathes.

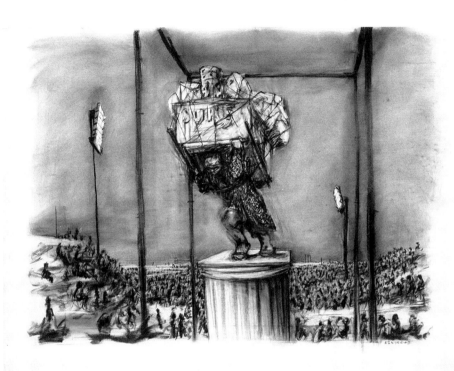

Fig. 5. William Kentridge, drawing for the film *Monument*, 1990. Courtesy of the artist

Kentridge's early processions have an evident monumental quality, as he seems to have been pondering the possibility of memorializing the daily suffering of people that he must have often encountered during the last years of the apartheid regime. Certainly, he must have been distressed by the celebratory aspect of the country's existing monuments and thought of them as reminders of the most terrible aspects of the colonial rule. In the film *Monument* (1990), in a reversal of what were certainly the facts in South Africa at the time, Kentridge portrays the inauguration of a monument that once unveiled is revealed to be a solitary porter, a figure as singular as it is anonymous, both isolated and omnipresent (fig. 5). What the porter does is to carry weight; her labor is a function of her sheer strength, and carrying is nothing but the most basic form of work, a primitive activity shared by men and beasts. By simply carrying, the porters in Kentridge's drawings and tapestries become progressively monstrous, like the pylon lady (plates 6, 18) or the loudspeaker man (plates 15, 27), but it is in their monstrosity that they finally assert their agency and singularity. These figures monumentalize the conditions to which they have been subjected, what we have done and never ceased to do to them.

As noted, the porters in the *Puppet Drawings* are tentatively "drawn" with pieces of torn construction paper. They are dark as shadows and made of scraps. It is only through their potential movement that they become animated, so they can go ahead with their task, which is both mythical and historical. They are of South Africa, but only insofar as they can be found anywhere, a language of shadows that often supports people's dreams and realities. In the tapestries, as in the *Puppet Drawings*, they pass across the beautiful background of colorful

maps from a nineteenth-century atlas, originally drawn as a tool for education. Some of the maps correspond to ancient Europe, others to medieval and modern times, projecting an endless passage of porters both to the future and the past. It would be a mistake to understand this work as manifesting an abstract universal human condition. What the procession of the porters protests, on the contrary, is the very possibility that any historical situation could be misunderstood as an existential fact. In its shattered insistence, the endless passage of the porters signals a painful historical reality that extends itself in space and time—neither a universal attribute of the human condition nor an unavoidable destiny for human lives. Restlessly, the porters have passed beyond the confines of the "second greatest city after Paris" to continue painfully traversing the whole wide world.

A LITERARY LANDSCAPE

The topography that Kentridge's processions traverse is somewhat blurred. In *Johannesburg, 2nd Greatest City After Paris*, for example, suddenly, the living and the dead, the porters and their animals and tools appear in the middle of town, as if the thief and the miner, the warrior and the wounded would have come out of absolutely nothing—as if emerging from the shadows. But another itinerary can perhaps be guessed, one that would have taken them from the country to the city, from the farms and the mines to the townships and then to the central streets and the well-to-do neighborhoods of the still-booming Johannesburg. Interestingly, the very production of the tapestries replicates that movement. The mohair from which they are woven comes from a farm in Swaziland, where the goats feed on the grass covering the slopes and the valleys of the mountains of the Transvaal. The wool is spun and tinted before it arrives at the tapestry workshop in urban Johannesburg. The tapestries could be thought to monumentalize, perhaps unintentionally, the history of the landscape in relation to the city—not the landscape of the Transvaal itself, glorious and wildly picturesque, but the landscape as inscribed in the struggles of the people for the land that, as Okwui Enwezor and Ivan Vladislavić clearly describe in their essays in this catalogue, has been the subject of some of the most fascinating novels and works of art to emerge from South Africa in the last few decades.

This catalogue is organized around the poles of that tension, and its very structure mimics the passage from the imagined or imaginary landscape on which the drawn figures appear to the actual landscape from which they unequivocally come. Along with the processions of porters, the landscape is a constant presence throughout Kentridge's oeuvre. This catalogue hopefully testifies to the fact that his is always a literary landscape, drawn by the human imagination and reconfigured by human struggles. No less real, in fact, than maps or works of art, the literary landscape establishes with them an endlessly evolving conversation to which Kentridge's work seems particularly well attuned. In addition to the works in the exhibition, the catalogue also illustrates some of the source maps for the drawings and tapestries as well as photographs of the process of making the tapestries that take the

viewer from the farmland to the workshop in the city, in a passage always mediated by human labor. In the context of Kentridge's artistic practice, which has always been a meticulous recording of its own coming into being, it is not surprising that work would become a central theme. In fact, labor, in its barest, most elemental form, is perhaps what the tapestries monumentalize, both through their subject matter and by the process of their own making. The naked fact of labor constitutes the crux of these works, their possibility, and the raison d'être of the porters that they ambiguously celebrate. The most unmerciful and harshest form of labor, that seemingly reduces the porters to beasts and objects without ever outshining their vitality, their will to be.

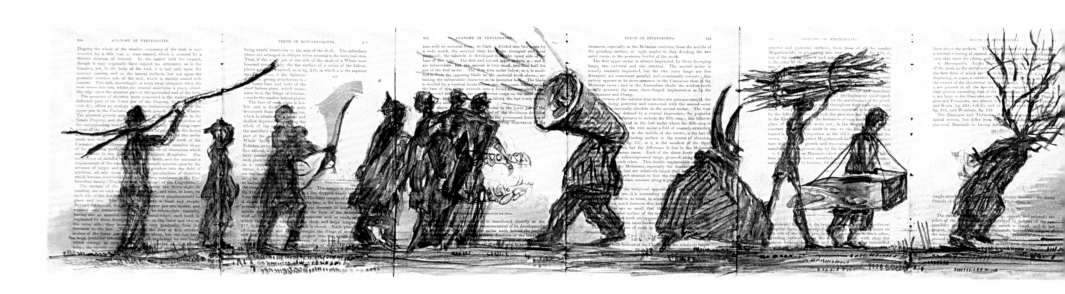

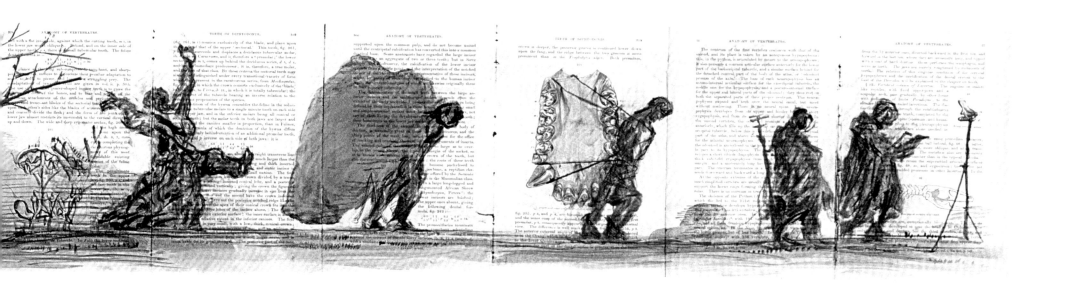

PLATE I

Procession on Anatomy of Vertebrates, 2000

Charcoal on book pages
8½ x 66¹⁵⁄₁₆ inches (21.6 x 170 cm)
Collection of Brenda Potter and Michael Sandler, Beverly Hills, California

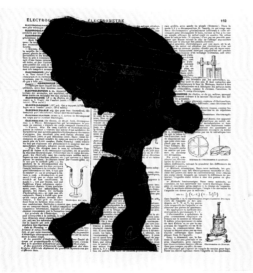
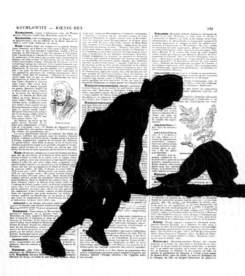
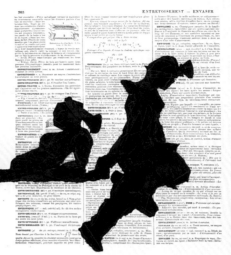
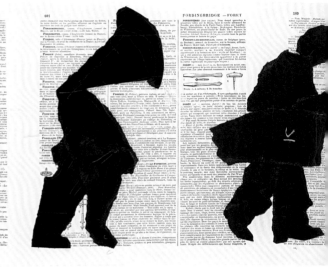
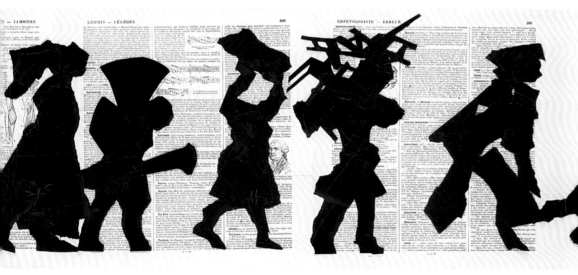
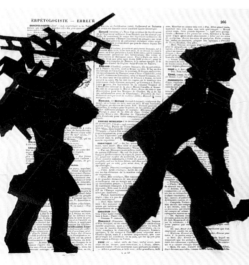
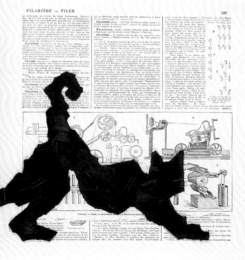
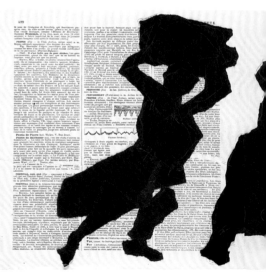

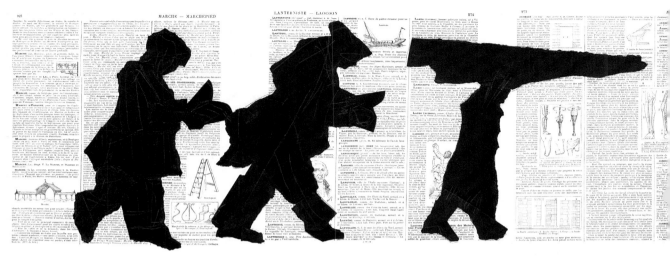

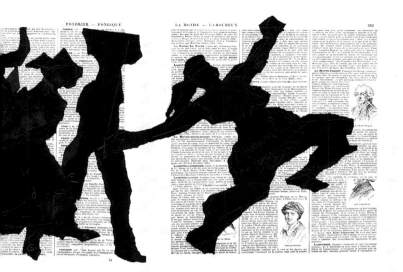

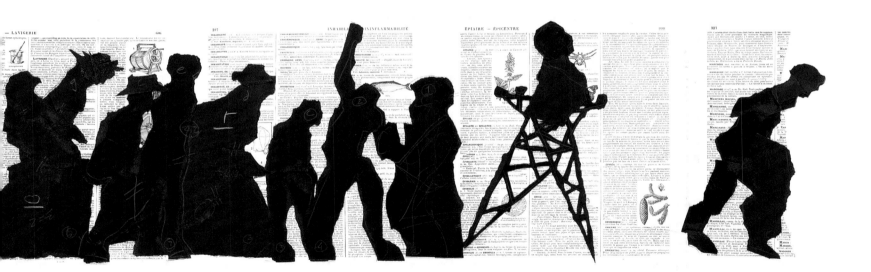

PLATE 2

Portage, 2000

Chine collé of figures from black Canson paper on pages from *Le Nouveau Larousse illustre* (c. 1906),
on Velin Arches Crème paper, folded as a leperello
Image 10¹³⁄₁₆ x 166½ inches (27.5 x 423 cm); portfolio (folded) 11⁷⁄₁₆ x 10¹⁄₁₆ x ¾ inches (29 x 25.5 x 2 cm)
Collection of the artist

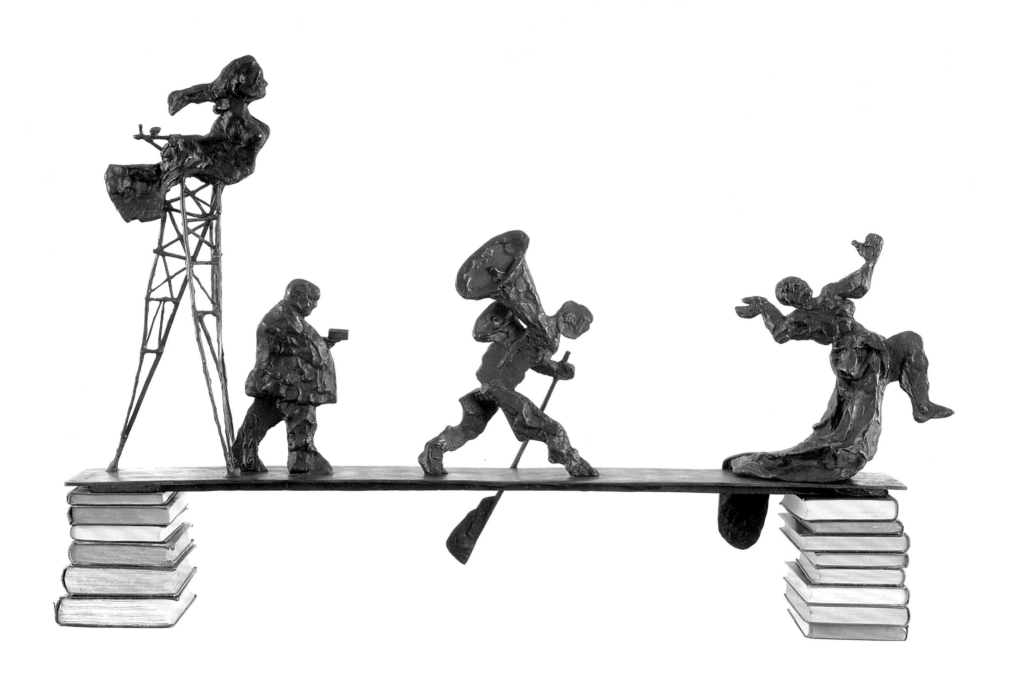

PLATE 3
Bridge, 2001

Bronze with books
23⅝ x 36¾ x 7½ inches (60 x 93.2 x 19 cm)
Collection of the artist

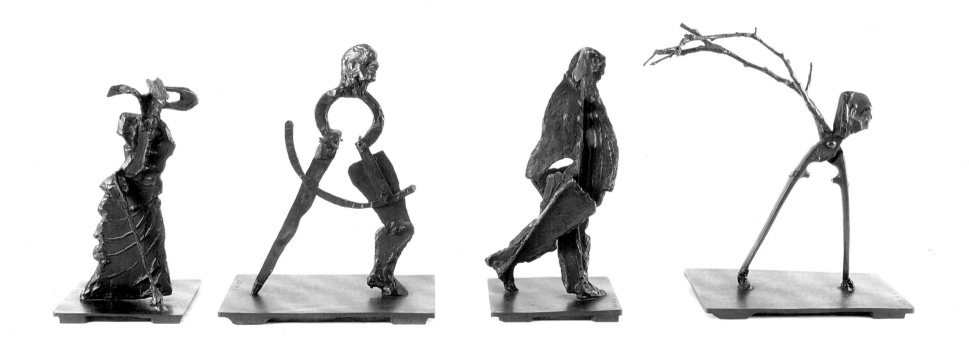

PLATE 4
Promenade II, 2002

Bronze
Tallest figure 14¾ x 10⁵⁄₁₆ x 6¾ inches (37.5 x 26.2 x 17 cm)
Collection of the artist

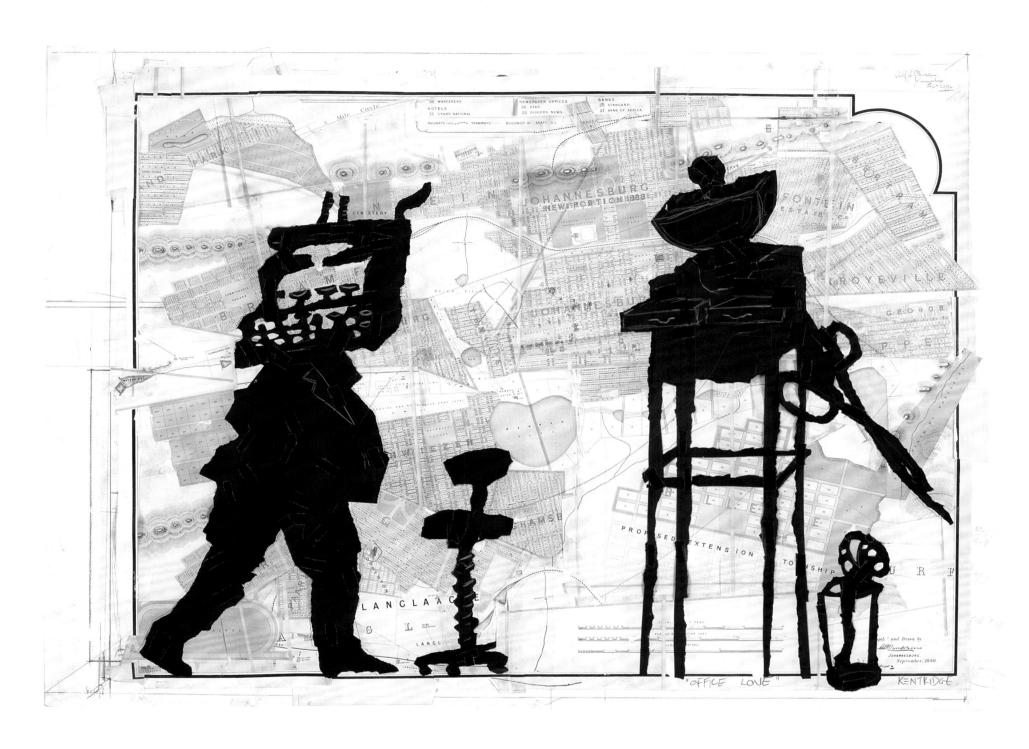

PLATE 5
Untitled Study for Tapestry (Office Love), 2001

Chine collé and collage
28¾ x 37¹³⁄₁₆ inches (73 x 96 cm)
Johannesburg Stock Exchange, South Africa

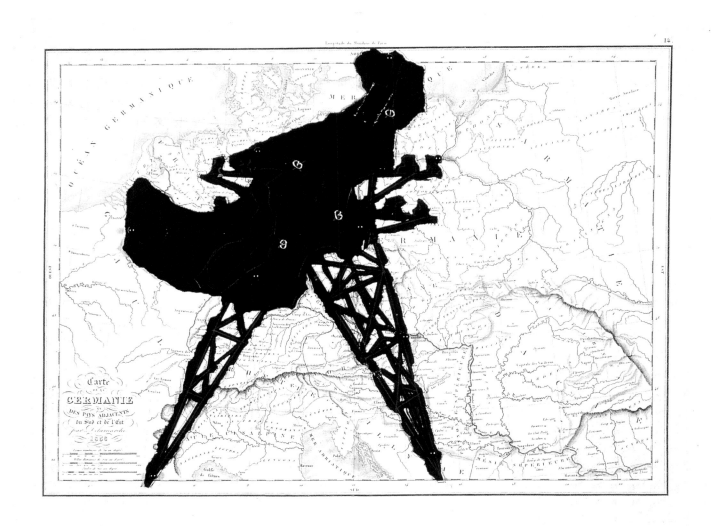

PLATE 6

Puppet Drawing, 2000

Collage, construction paper, tape, chalk, and pins on atlas page
13¼ x 18¾ inches (33.7 x 47.6 cm)
Private collection

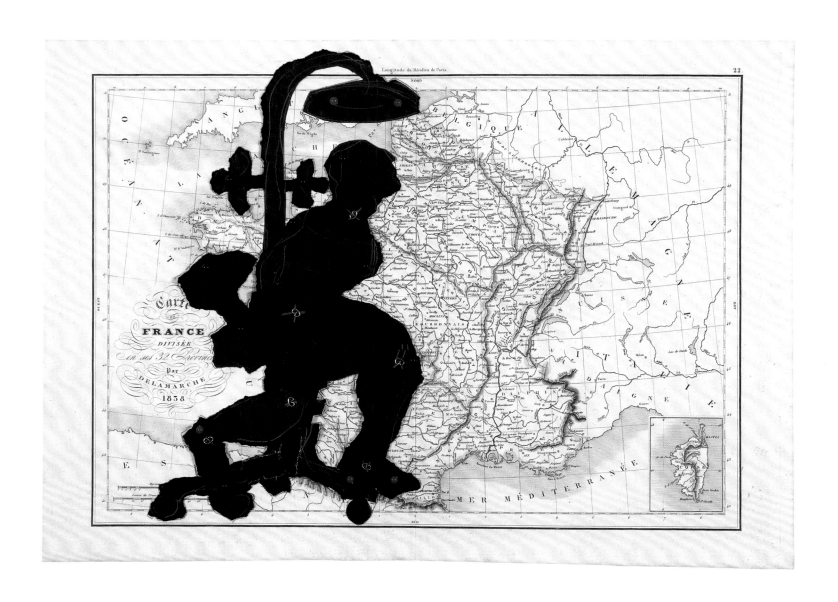

PLATE 7
Puppet Drawing, 2000

Collage, construction paper, tape, chalk, and pins on atlas page
13¼ x 18¾ inches (33.7 x 47.6 cm)
Private collection

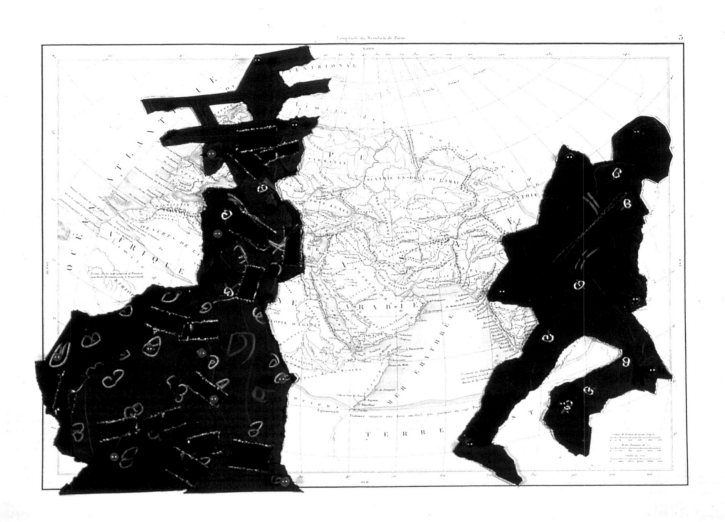

PLATE 8

Puppet Drawing, 2000

Collage, construction paper, tape, chalk, and pins on atlas page
13¼ x 18¾ inches (33.7 x 47.6 cm)
Collection of Bette Ziegler, New York

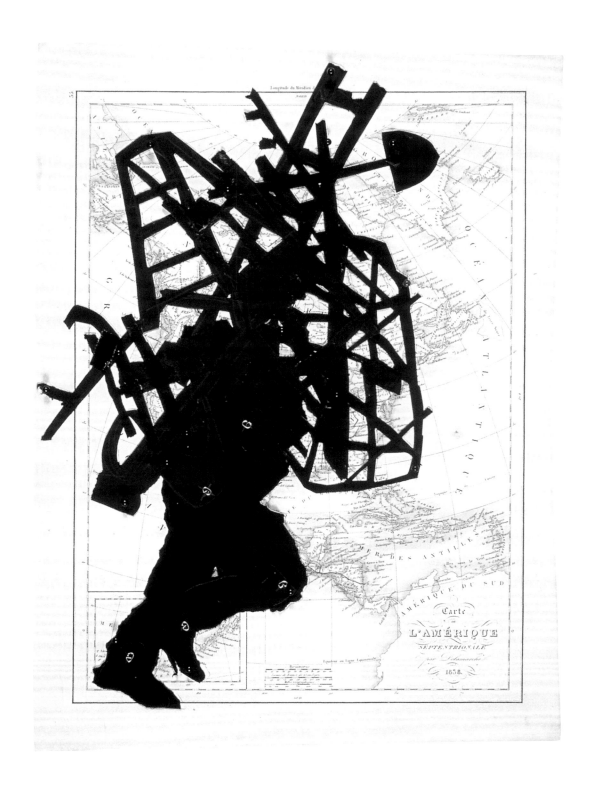

PLATE 9
Puppet Drawing, 2000

Collage, construction paper, tape, chalk, and pins on atlas page
18¾ x 13¼ inches (47.6 x 33.7 cm)
Marc and Livia Straus Family Collection

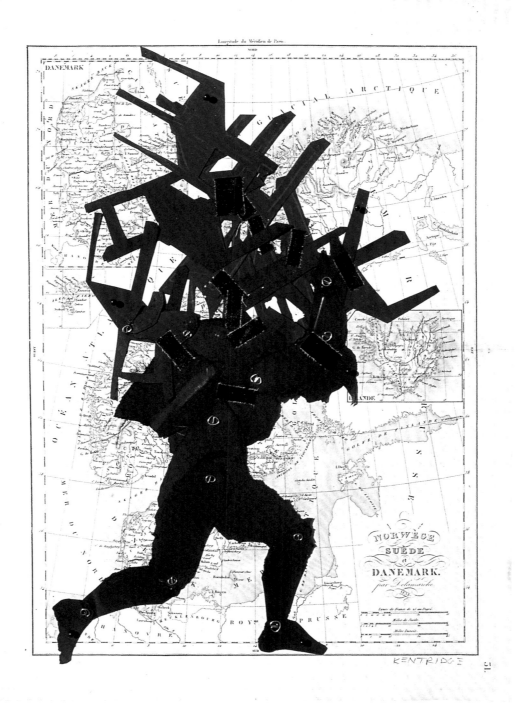

Puppet Drawing, 2000

Collage, construction paper, tape, chalk, and pins on atlas page
18½ x 13⅜ inches (47 x 34 cm)
Collection of Edwin C. Cohen, New York

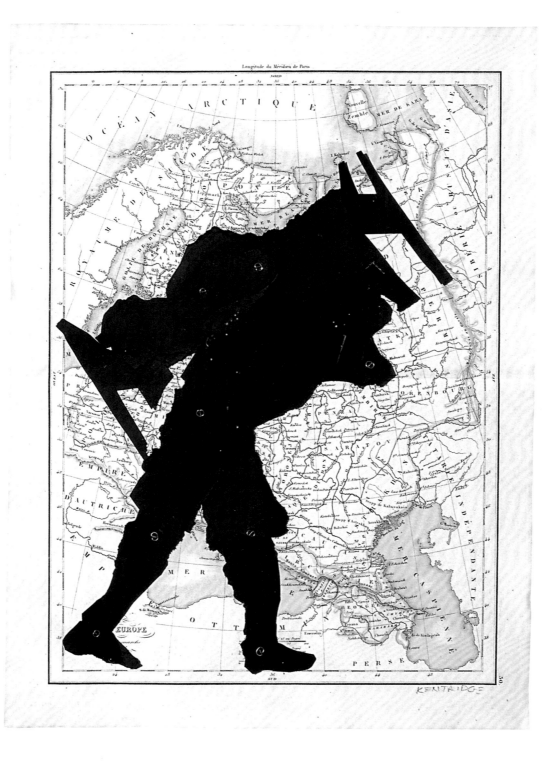

PLATE 11

Puppet Drawing, 2000

Collage, construction paper, tape, chalk, and pins on atlas page
18½ x 13⅜ inches (47 x 34 cm)
Collection of Melva Bucksbaum and Raymond Learsy, Connecticut

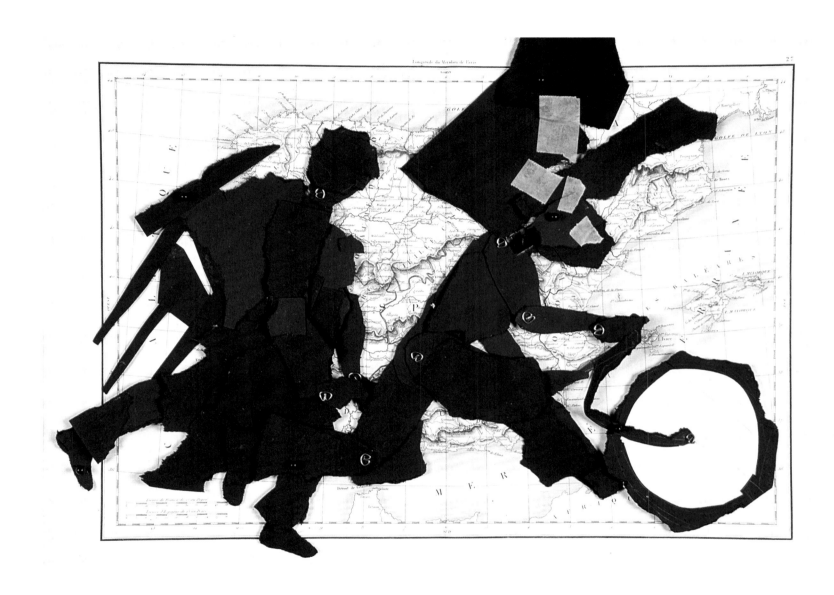

PLATE 12

Puppet Drawing, 2000

Collage, construction paper, tape, chalk, and pins on atlas page
13⅜ x 18½ inches (34 x 47 cm)
Collection of Brenda Potter and Michael Sandler, Beverly Hills, California

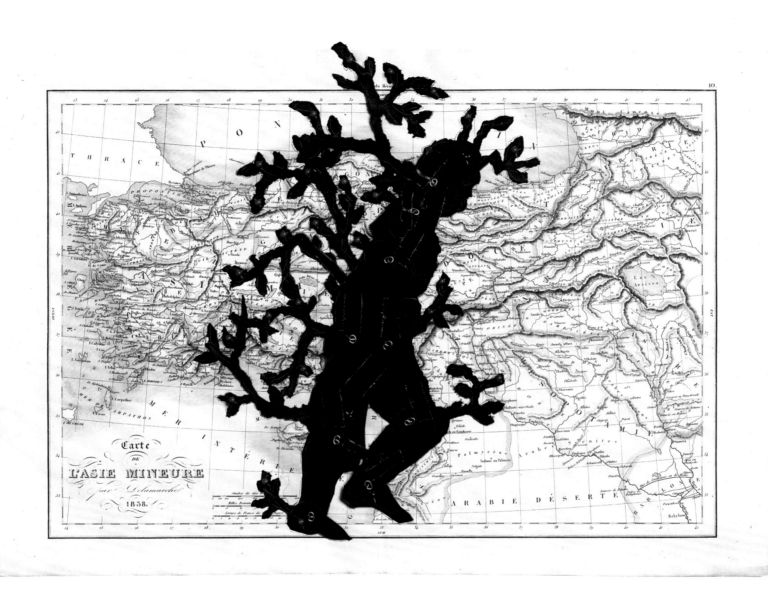

PLATE 13

Puppet Drawing, 2000

Collage, construction paper, tape, chalk, and pins on atlas page
13¼ x 18¾ inches (33.7 x 47.6 cm)
Private collection

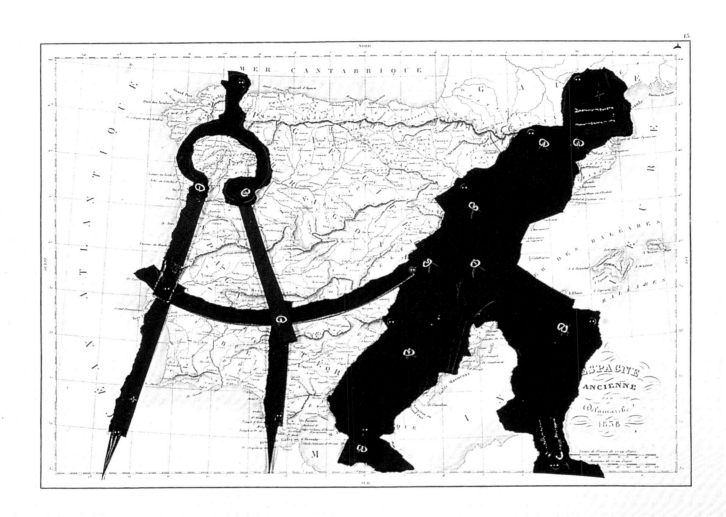

PLATE 14

Puppet Drawing, 2000

Collage, construction paper, tape, chalk, and pins on atlas page
13¼ x 18¾ inches (33.7 x 47.6 cm)
Private collection

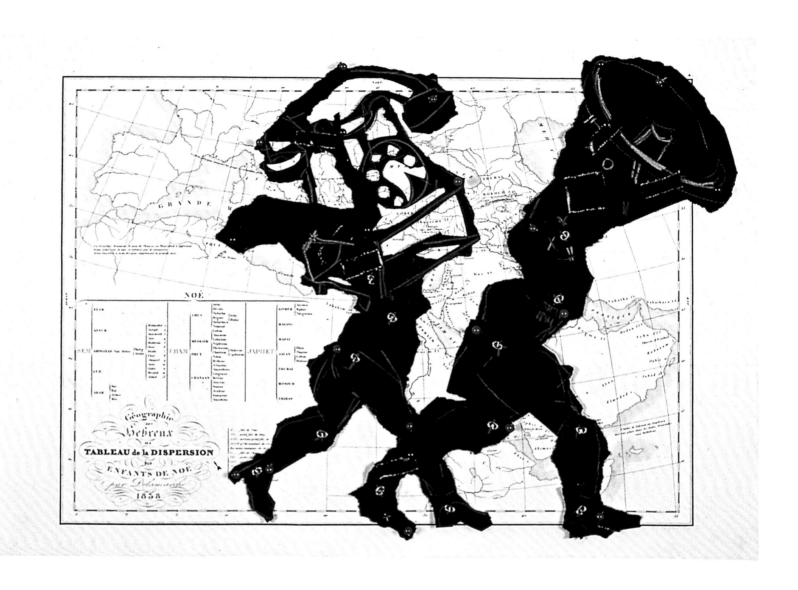

PLATE 15
Puppet Drawing, 2000

Collage, construction paper, tape, chalk, and pins on atlas page
13¼ x 18¾ inches (33.7 x 47.6 cm)
Collection of Dr. and Mrs. Jerry Sherman, Baltimore

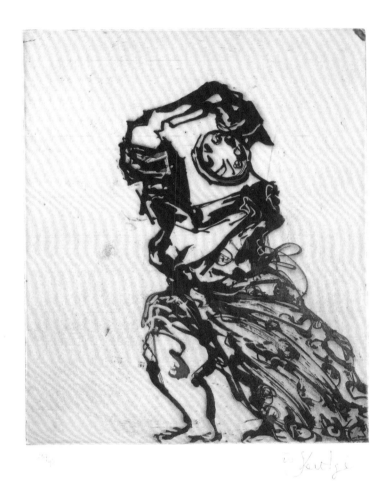

16a

PLATES 16A–I

Zeno at 4 a.m., 2001

Series of nine etchings and aquatints
Plates 9¾ x 7¹³⁄₁₆ inches (24.7 x 19.8 cm) each; sheets 14 x 11⅝ inches (35.6 x 29.5 cm) each
The Museum of Modern Art, New York, Mary Ellen Meehan Fund, 2001

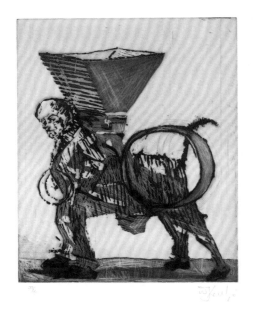

16b

16c

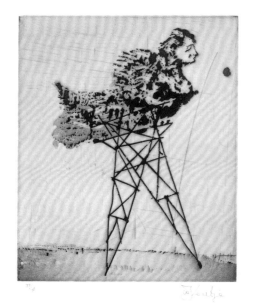

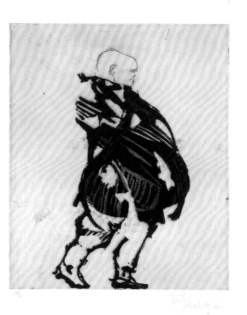

16f

16g

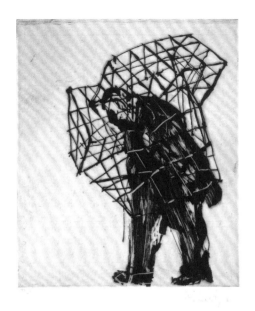

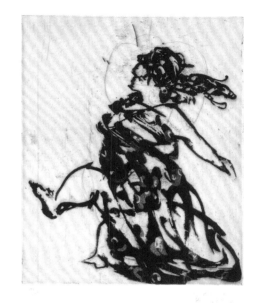

16d

16e

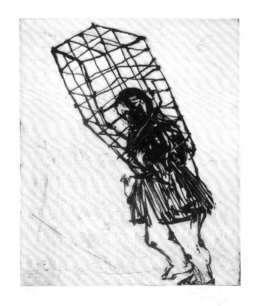

16h

16i

n; its blade is divided into two cones by
ior cone being the strongest and most
s developed from the inner side of the
rst and second upper molars, m 1 and 2,
second is very small, less than half the
he first true molar below, m 1, is modi-
blade to the sectorial tooth above; re-
aracter at its posterior half. The blade
ear fissure into two cones, behind which
tends into a broad triuberculate talon
as two anterior cusps on the same trans-
flat talon; the last lower molar,
molar in the lower jaw of the
racter of the deciduous dentition
crown to the permanent dentition of
an interesting illustration of the

ment teeth in the Dog (Canis).

is manifested directly as the
commencement of its development
molar teeth behind the perma-
manent dentition of the lower
for a greater variety of climates
aces, all of which tend, in an important

instances, especially in the Melanian varieties, from the middle of
the grinding surface, at right angles to that dividing the two
outer cusps, to the posterior border of the tooth.

The first upper molar is always implanted by three diverging
fangs, two external and one internal. The second molar is
usually similarly implanted, but the two outer fangs are less
divergent, are sometimes parallel, and occasionally connate; this
variety appears to be more common in the Caucasian than in the
Melanian races; and in the Australian skulls the wisdom tooth
usually presents the same three-fanged implantation as in the
Chimpanzee and Orang.

The crowns of the inferior true molars are quinque-cuspid, the
fifth cusp being posterior and connected with the second outer
cusp; it is occasionally obsolete in the second molar. The four
normal cusps are defined by a crucial impression, the posterior
branch of which bifurcates to include the fifth cusp; this bifurca-
tion being most marked in the last molar where the fifth cusp is
most developed. In the first molar a fold of enamel, extending
the inner surface to the middle of the crown, is the last to
the grinding surface in the course of abrasion.
tooth, fig. 257, m 3, is the smallest of the three
rows, but the difference is less in the Melanian
Caucasian races. Each of the three lower
inserted two sub-compressed fangs, grooved along
each other. This double implantation ap-
the Melanians, especially the Australian
the molars are relatively larger than in
it is not unusual to find the two in both the
second and molars connate along a great part of the length

the reciprocal apposition of the teeth of the
jaw, it is interesting to observe that the crown
canine is, as usual, in advance of that above, and fits
low notch between that and the lateral incisor. The
incisors are so small that the anterior surface rests
the terior surface of the up when the mouth
other teeth are opposed crown to crown, the upper
teeth little more outward than the lower ones.
The series of teeth in fig. 258
consists of—

$$i\,\frac{2.2}{2.2};\ c\,\frac{1.1}{1.1};\ m\,\frac{2.2}{2.2} = 2$$

The upper milk incisors of the Chimpanzee are relatively larger

Becoming Aware in a World of People on the Move

GABRIELE GUERCIO

THE TAPESTRIES

Since 2001, William Kentridge has completed a series of seventeen tapestries, each in multiple copies or versions. They originate in the artist's collages of black silhouettes cut and glued over reproductions, mostly from nineteenth-century geographical atlases. The weavers then use a photograph of the collage as the basis for turning the image into tapestry. The tapestry series is the result of a successful collaboration between the artist and Marguerite Stephens and her workshop. Her tapestry studio, established in 1963 in Swaziland, promotes tapestry through technical excellence, the use of hand-carded and -spun mohair from South Africa, and a careful rendering of the drawings supplied by artists. Interpreting and adapting Kentridge's compositions, Stephens and the members of her workshop have made it possible for a body of remarkable images to acquire a new status through an ancient practice.

Tapestry is one of the oldest forms of woven textile and probably the procedure most suited to creating pictures by weaving.[1] Known since antiquity in Egypt (fig. 6), Asia, and Pre-Columbian America, the production of tapestries developed more or less independently in each of these regions. While their basic function has always been that of wall-covering, and while their textures have changed little through the ages, tapestries may present multifarious visual features—from abstract patterns and symbolic representations to eloquent narratives and colorful decorations—and may answer needs of a religious and spiritual nature or simply satisfy the demands of interior decoration.

Tapestry's fortunes have fluctuated in the West. Surely, they formed an important part of the visual environment in urban antiquity. As the Greeks and the Romans invaded neighboring territories or were exposed to Eastern cultures, they started treasuring tapestries from Babylon, Egypt, Persia, and India, bringing an appreciation of the technique to the West. In modern Europe, the destiny of tapestry depended upon shifts in taste and changing perceptions of the roles played by the weaver and the artist-designer. For instance, medieval tapestry transformed the medium both by augmenting the narrative connotations of the pictures and by leaving weavers free to create their own images, usually adapted from illuminated manuscripts. The early sixteenth century saw a reversal of these priorities, as working sketches by artists became full-sized drawings, or cartoons, which the weavers had to copy with utter precision. This practice is epitomized by Raphael's cartoons for *The Acts of the Apostles* (fig. 7), a group of tapestries intended to hang on the lower walls of the Sistine Chapel.[2] Never before had an artist taken such complete control over the creative process. Raphael's cartoons gave the Flemish weavers of the workshop of Peter Coecke van Aelst—who in 1515 was commissioned by Leo X to execute the tapestries—detailed specifications as to shape, size, tone, and color of the final pictures. From then on, the artist's role in tapestry design grew as the weavers' creative input diminished. Working now with greater creative control, numerous artists prepared cartoons for tapestries, from Raphael's contemporaries Giulio Romano, Pontormo, and Titian to

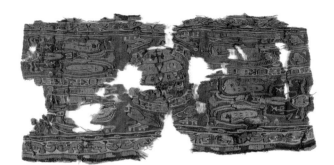

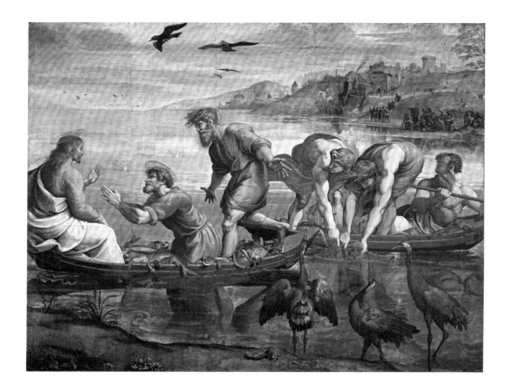

Fig. 6. *Tapestry Fragment*, Egyptian, 8th century. Linen and wool; 13¾ x 6⅞ inches (35 x 17.5 cm). Philadelphia Museum of Art, Gift of Mr. and Mrs. John Harrison, 1905-463b

Fig. 7. Raphael (Italian, 1483–1520), *The Miraculous Draught of the Fishes*, 1515–16. Bodycolor on paper mounted onto canvas (tapestry cartoon); 118⅞ x 121⅝ inches (302 x 309 cm). Victoria and Albert Museum, London

Peter Paul Rubens and Pietro da Cortona, whose impressive *History of Constantine* tapestry series of 1623–30 is now at the Philadelphia Museum of Art (fig. 8).[3] Later artists such as Nicolas Poussin, Charles Lebrun, François Boucher, Edward Burne-Jones, Henri Matisse, Fernand Léger, Mario Sironi, and Alighiero e Boetti (fig. 9) at some point in their careers made designs for tapestries. Notwithstanding a handful of influential advocates for the artistic merits of tapestry—including William Morris, Jean Lurçat, and Le Corbusier[4]—it is today classed mainly in the realm of craft rather than art unless it can be associated authoritatively with the artist who designed it.

The sharp divide between art and craft has deeply affected tapestry's reputation in the West. Renaissance artists and writers initiated this rift, privileging works in painting and sculpture as the offspring of a liberal practice intermediating between the perceptions of the outside world and the visions of the artist's imagination.[5] The divide was fully achieved, however, only in the eighteenth century with the foundation of the beaux-arts system.[6] Following this development, ancient views of *tekhnê* as an all-encompassing activity and of creativity as a generic human faculty dropped from discussions of artistic phenomena.[7] These two complementary views had still been influential during the Renaissance because of its emphasis on the universal bearing of *disegno*, or drawing.[8] But they lost credence as eighteenth-century artists and writers on art began to value almost exclusively the semiotic and aesthetic properties deemed intrinsic to each particular artistic form. The modern system of the arts saw to it that the products of a restricted set of practices—painting, sculpture, poetry, music, and (often alternatively) architecture, dance, and garden design—be appreciated in terms of disinterested pleasure, specific demands of

their mediums, and achievements internal to their historical developments. Because they were said to evince genius and inventiveness and to prompt judgments of taste and insights into specialized areas of competence, works in painting, sculpture, and other "elevated" mediums were set apart from products made by reiterated technical operations and for utilitarian purposes. This discrimination between art and craft, artist and artisan, helped to establish the autonomy of works of art. It placed them within a realm of illusion, deliberately aloof from the dynamics of the world and reality at large, by differentiating artistic experience from other experiences and by circumscribing the potentially unlimited manifestations of human creativity to a quantified number of artistic activities. These radical distinctions made tapestry's "artistic" status uncertain. As the beaux-arts gained prestige, the taste for and market value of tapestry waned.[9] No longer a precious collectible, tapestry was valued no more than other household items. Its appeal, when felt, was due to its decorative appearance and versatility. Subsequent calls for a revaluation of tapestry, when they came, often attempted to align it with other supposedly major arts, primarily painting, and thus implicitly ratified the very principles of the modern system that had devalued tapestry in the first place, without esteeming human creativity over and above the material basis of its heterogeneous outlets.

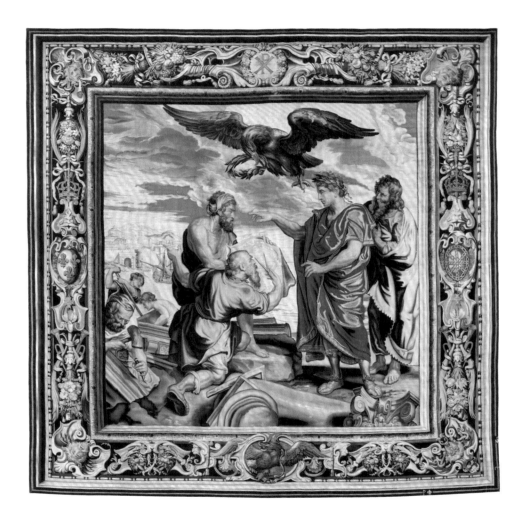

Fig. 8. *Constantine Directing the Building of Constantinople*, 1623–25. Tapestry designed by Peter Paul Rubens (Flemish; active Italy, Antwerp, and England, 1577–1640); woven at the Comans–La Planche tapestry factory, Paris; workshop of Filippe Maëcht and Hans Taye. Wool and silk with gold and silver threads; 190½ x 189 inches (483.9 x 480.1 cm). Philadelphia Museum of Art, Gift of the Samuel H. Kress Foundation, 1959-78-7

William Kentridge's tapestries partake to some extent in the complex history of tapestry, which I have only hinted at above. But they also depart from it, defying some of its recurrent assumptions. While endorsing the narrative bent of Western tapestries, they do not fulfill the expectations of décor, luxury, and status commonly linked with tapestry. Their subject matter compels one to think of human mobility in its extensive sense of global outgrowth and confrontation with otherness within and without oneself. It is a subject whose visual pregnancy cannot be appraised simply in terms of disinterested aesthetic pleasure, which, since the nineteenth century, has often been invoked to rescue tapestry from its declassed status as craft.[10] Nor would it be sound to ascribe to Kentridge's tapestries the ambition to secure a place for tapestry in the beaux-arts system. Like his other works, Kentridge's tapestries demonstrate a capacity not only for blurring the gap between craft and art, but also for subverting the pretense of placing artistic phenomena within fixed categories.

In suggestive ways, Kentridge's tapestries revive and address issues germane to his other work to date.[11] They conjure a scenario of human movement and proximity on a planetary scale; reclaim the cinematic core of Kentridge's images; question the ambivalence of "shadows" in Western theories of knowledge; and posit the

activity of drawing as a potentially unlimited experience. Arguably, here as in other of his works, Kentridge's imagery unfolds through unceasing mediations (formal, cultural, historical, etc.) and yet does not presuppose or confide in any strict identification between a work of art and its physical and semiotic outlook. Rather it points to the flexibility of human creativity and calls for a renewed grasp of its unconditional nature.

IMAGES OF PEOPLE ON THE MOVE

Kentridge's tapestries tell of a world of people on the move. The foregrounds show one or two black silhouettes against overall reproductions of maps representing various parts of the planet. I will discuss the silhouettes' shadowy character below, but here I wish to deal with their immediate thematic implications. The black silhouettes or shadows are reminiscent of sequences of multiple figures in procession found in Kentridge's videos, artist's books, and sculptures as early as *Arc/Procession Study* (1989) and *Arc/Procession: Develop, Catch Up, Even Surpass* (1990), and thereafter in *Shadow Procession* (fig. 10), *Portage* (fig. 11; plate 2), and *Procession* (2000). Although figures appear in the tapestries only one or two at a time, they are nevertheless caught in what seems like a procession. Their positions and postures suggest a momentary halt within motion. Except for *Office Love* (plate 17), the tapestries share the title *Porter Series*, with changing subtitles. The porter is a favorite motif with Kentridge. The job of a porter—somebody carrying a load on his or her back or head—exemplifies labor in its basic demand for physical energy. Key to the associations evoked by the tapestry series are the maps in the background. Depicting Spain, the Atlantic,

Fig. 9. Alighiero e Boetti (Italian, 1940–1994), *The New Autonomies*, 1988. Embroidery on muslin; 40 x 40 inches (101.6 x 101.6 cm). Philadelphia Museum of Art, Gift (by exchange) of Mr. and Mrs. Arthur A. Goldberg, 1998-70-1

Asia, the Arctic, and other places, the maps date to the first half of the nineteenth century, a period that witnessed a significant increase in human mobility and migration, which to varying degrees has characterized the planet since hominization.[12] The maps hint that the silhouettes and territories may be somewhat related. This pairing sets the narrative tone of the woven pictures by evoking situations of routing and resting, encounters and seclusion, solidarity and exploitation. In short, the *Porter Series* both entails and inspires a meditation on the ineluctable flux of human transits, industry, and contacts.

What can one say, however, about these porters moving across the earth? As depicted in the tapestries, their race, gender, and citizenship are ambiguous. They may be female or male, of African, European, or Asian ancestry. In one tapestry, the map's inscription reads "Geographie des Hebreaux" (plate 27). Diaspora, the name for the Jewish condition of dispersal enshrined in Deuteronomy 28:25, seems to apply to them all. No longer pertaining to a single people, diaspora has become a way of life for all individuals and groups who migrate across geocultural borders. The *Porter Series* allows one to imagine that, in their migration, the porters may cover long or short distances in a trail of arrivals and departures that began long before their time. Thus perceived, the *Porter*

Fig. 10. Installation of William Kentridge's film *Shadow Procession*, Times Square, New York, 2001. Courtesy of the artist

Series is a reminder that—whether mass- or small-scale; whether willed or forced (and often it has been the latter); whether propelled by open-mindedness and longing for unknown lands or compelled by famine, discrimination, and hope for a better life—migration is a decisive feature of modernity. In the three centuries after Columbus's voyage in 1492, some two million Europeans crossed the Atlantic to settle in the Americas, while nearly eight million Africans were brought there, most of them in slavery.[13] Migration has affected modernity in its concomitant dramas of colonization and decolonization and has driven globalization in the twentieth century.

Both experientially and conceptually, migration challenges the belief in progress that is one of the foundations of the nation-state—a culturally homogeneous society occupying a distinct territory, governed by a unitary lawful structure. Created in part as a deterrent to the distressing effects of migration, the notion of the nation-state gained full currency in Euro-American societies in the nineteenth century, when the maps reproduced in the *Porter Series* were compiled. Despite these geopolitical interdictions, the protagonists of Kentridge's tapestries undertake transnational moves by walking (defiantly? dangerously?) across the frontiers marked by the maps. Their cinematic postures upset static configurations of the world while infringing spatiotemporal barriers.[14] The random graphemes inscribed on the black silhouettes signal points of tension caused by forces presumably sprung from the transient entanglement of bodies and territories. Moreover, the fact that the porters carry an assortment of objects (a bed, chairs, a telephone, a megaphone, a gigantic compass) and that one of them is metamorphosing into a tree indicates that their physical exertion does not preclude their mental and emotional engagement. Indeed, the telephone and megaphone are anachronistic; their inclusion not only contradicts the historical dates of the maps, but also insinuates that the porters may be heralds of futures yet unseen, or perhaps agents of other experiential times undetectable within the totalizing scheme of humankind's chronological progress. The idea of progress implied by the maps has been put to harsh use by modern countries imposing models of Western development upon people supposedly without history. Thus the anachronisms in Kentridge's images testify against uniform conceptions of progress. They hint, implicitly, that the changing of patterns of life on earth—results of a contest between monopolistic power and human freedom—manifest themselves as much in changing uses of space and territory as in perceptions of time and history.

Yet the *Porter Series* keeps the porters' identities complicated. It is hard to discover what exactly motivates the porters in their motion. It could be a vexing search for a means of survival as much as a restless exploration

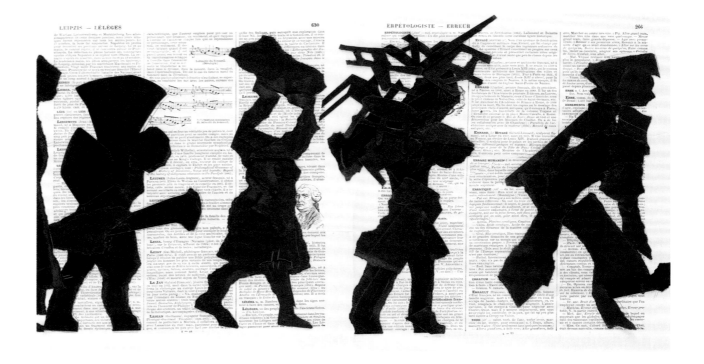

of new horizons. The black silhouettes might stand for settlers, nomads, slaves, refugees, or invaders. On the one hand, they can be seen as stateless outcasts, people who find themselves excluded from the privileges of citizenship and reduced to a "bare life" in subsisting in a zone alienated from subjective rights and juridical protection.[15] Following this line of reasoning, the porters bring to mind the condition of subalternity endured by workers and colonized subjects oppressed by hegemonic powers in many countries and at many periods in history. On the other hand, the porters' movements may also answer a positive need to make one's voice heard (with a megaphone?) or to chart (with a compass?) global spaces where habitual perceptions about centers and peripheries would be superseded by the recognition that people's proximity to environments is always being negotiated. The porters, that is, announce that there are no permanent zones of indistinction, that the relationships between sovereignty and territoriality can be reconfigured.[16]

But the multiple meanings of the porters' identities is probably essential to what the *Porter Series* seeks to envision. Migration is qualified by instability, by the traumas, mutations, and epiphanies occurring through territorialization and deterritorialization. Transits affect both bodies and minds. Human beings enter into what contemporary anthropologists call "contact zones"—areas where individuals, hitherto geographically and historically separated, clash and interact within uneven relations of power.[17] The *Porter Series* alludes to the tremors of these contact zones. It visualizes what has become apparent in our new global cultural economy: that increasing diasporas of people cause hybridization among subjectivities, cultures, and languages; grant relations that both recognize

and safeguard the opaqueness of others; stimulate rhizomic aggregations that reshape the earth and its inhabitants, whose feelings of community are now attached to imagined worlds and "ethnoscapes."[18] Finally, frustrating interpretations of the porters' identities as specimens of "otherness,"[19] the *Porter Series* may suggest that the black silhouettes resist detection because they represent individuals whose lives run parallel to those of the dominant social classes and yet remain impervious to their codes. Precisely by being imponderable, the porters epitomize what is today perceived as an emerging collective intelligence, which needs no head to lead its political body since it is itself the enlightened, immaterial heart of the global system of production. Through its perpetual exodus, the collective of the porters therefore manages to defy and subtract itself from the forced recruitment of all the psychophysical energies of individuals to the cause of capitalism in its post-Fordist and multinational phase.[20]

The interplay between background and foreground—the porters' opacity and the maps' decipherability—kindles the narrative purport of the woven images without prescribing a univocal direction of sense. In doing so, it aptly thematizes the unknown elements inherent to transiting and becoming. We begin to fathom, then, one of the reasons why the porters must be "shadows." Shadows entertain a difficult relationship with reality and yet have played a significant role in human experience since antiquity. As shadows cast over the world, the images of the porters intensify the sensitivity to oneself as "other" and to another as oneself—a sensitivity that modernity has prepared us for and that now, in our globalized world, is a daily routine for the masses of cosmopolite workers who increasingly encounter and interact with strangers. But the shadow nature of the porters also elicits an exploration of the potential alliances encircling visible and invisible domains, seeing and knowing, thoughts and imagination. Hence the *Porter Series* inaugurates another course of associations, which verge upon the metaphysical dilemma of distinguishing the true from the illusory world—a dilemma that shadowgraphy both exploits and frustrates.

SHADOWGRAPHY AND THE OVERCOMING OF PLATONISM

Shadowgraphy, or the making of images by throwing shadows, ranges from the simple trick of conjuring a rabbit's shadow with one's hands to the sophisticated devices used in theater, painting, viewing machines, photography, and cinema. Humans seem to have an enduring fascination with shadows. In ancient and modern cultures alike, they have been regarded as double, virtual bodies or as reflections of the soul, and they have been studied in both science and art for what they can tell us about perception.[21]

Shadows, moreover, are central to two mythical accounts of origins. The first is the famous philosophical parable found in Plato's *Republic* (7.514–515), in which the human condition is likened to that of prisoners trapped in a cave, who, seeing only the wall opposite the entrance, deem as real the shadows cast on the wall by figures and objects placed behind them and illuminated by a fire. Only when the prisoners are let loose and turn

around can they start ascending from error to the lights of true knowledge. The second account concerns the origin of portraiture as narrated by Pliny the Elder (*Natural History* 35.43). He reports that Butades, a potter of Sicyon, invented clay portraiture because his daughter, in love with a young man who was going abroad, drew in outline on a wall the shadow of his face thrown by a lamp. Butades pressed clay inside the outline and made a relief, which he hardened by exposure to fire, thus creating a lasting semblance of the youth. Both of these stories ascribe great power to shadows. Pliny, who had previously noted that the art of painting also was said to have begun with tracing someone's shadow (*Natural History* 35.15), positively associates shadows with artistic representation, as well as with an image's peculiar ability to compensate for absence, if not death, by preserving someone's effigy. For Plato, by contrast, shadows share with mirrors and pictures the deceptive power of a mere apparition or eidolon. They induce humans to trust the illusory data of the senses and to ignore the transcendental truth of ideas. Though for opposite reasons, both stories interestingly link shadows and images not only to each other, but also to the dynamics of becoming aware, whether that awareness is aroused by the creation/contemplation of a likeness or by the discovery of the intelligible order of reality. In Pliny's text, awareness implies trusting images, or shadows, because they capture identity and difference by keeping present persons or things that are absent. In Plato's parable, awareness means translating from appearance to reality so that mystifying differences and sense perceptions are redeemed by the cognition of trustworthy, immaterial identities.

In the *Porter Series*, Kentridge likewise endeavors to strike paths to awareness. His use of shadowgraphy generates images of otherness: effigies of porters whose identities remain indeterminate. As in Plato's allegory, the tapestries exhibit shadows of figures and objects presumably located behind the onlooker and the artist himself. As in Pliny's anecdote, the outlines impressed upon the woven pictures keep a visual memory of the departing porters.

At times, images of cast shadows alone assume a preeminent role in works of art. Writing to Émile Bernard in 1888, Paul Gauguin praised the calculated "strangeness" achievable in painting "if instead of a figure you put the shadow only of a person."[22] Gauguin's prescription, which could be applied to modern paintings ranging from Jean-Léon Gérôme's *Golgotha* of 1867 (fig. 12) to works by Giorgio de Chirico (fig. 13), Marcel Duchamp, and Pablo Picasso (fig. 14), reflects contemporary vogues with shadow and silhouette in Japanese prints, *théâtre d'ombres*, and pantomime. It proposes that contoured shapes should replace chiaroscuro and that a painting of shadow better demonstrates the artist's delving into hidden realms. This interest in shadows coincided with developments in photography[23] and protocinematic practices, particularly phantasmagoria. The latter, an entertainment popular after the French Revolution, consisted of a modified magic lantern projecting images of skeletons, demons, and ghosts onto walls or screens. Phantasmagoria made the moving image a vehicle for intimate exploration beyond physical space into something multidimensional: the phantasmal imagery of the mind itself, with its rather unaccountable mechanisms of perception and imagination.[24]

Fig. 12. Jean-Léon Gérôme (French, 1824–1904), *Golgotha*, 1867. Oil on canvas; 25 x 38⅝ inches (63.5 x 98 cm). Musée d'Orsay, Paris

Fig. 13. Giorgio de Chirico (Italian, born Greece; 1888–1978), *Italian Piazza*, 1912. Oil on canvas; 18½ x 22½ inches (47 x 57.2 cm). Collection of Dr. Emilio Jesi, Milan

Fig. 14. Pablo Picasso (Spanish, 1881–1973), *The Shadow*, 1953. Oil and charcoal on canvas; 49½ x 38 inches (125.7 x 96.5 cm). Musée Picasso, Paris

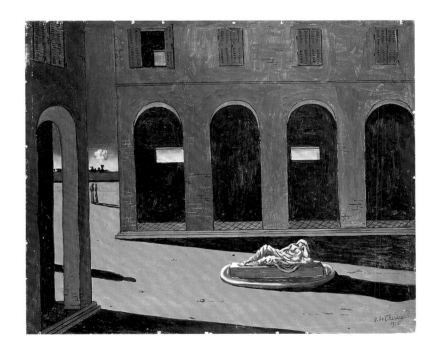

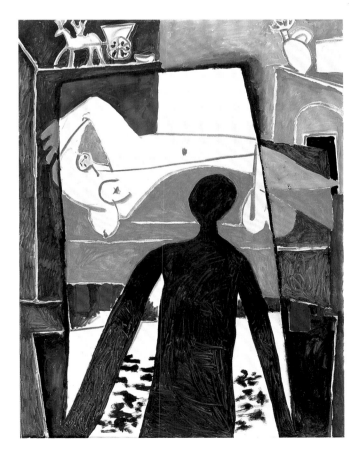

Kentridge's *Porter Series* revives this nineteenth-century interest in manifold states of consciousness by accentuating the phantasmal aspects of shadows and conveying a cinematic effect of spatiotemporal flow. However, the calculated strangeness of depicting cast shadows in itself fosters both disorientation and catharsis. Staging a shadow's revenge against Plato's verdict, the *Porter Series* stipulates that awareness is a process of coevolutionary coupling in which imagination and intellect, cogitation and emotion, do not split but rather cooperate as soon as one dispenses with assumptions about truth and illusion.

Explaining why he uses shadows in his work, Kentridge refers to Plato's parable of the cave and proposes a reverse journey: a descent from the brightness of the sun to the darkness of the cave. For Kentridge, Plato's parable not only anticipates cinema's mode of projection—the prisoners' condition being analogous to that of spectators in a movie theater—but it also affords insights into shadows themselves. To return to the cave is to yield to shadows' faculty for engendering awareness. Insofar as seeing "is always a mediation between this image and other knowledge," shadows "make the mediation conscious."[25] When human hands ingeniously evoke a shadow of something against a lit wall, we realize that the outcome is both a shadow of two hands with crossed thumbs and a shadow of an imagined rabbit or bird. We fluctuate between the realms of optics and physics and those opened up by a mindful attentiveness to the event. For Kentridge, coping with this dyad of responses, recognizing the pleasure of self-deception, is "fundamental in what it is to be a visual being." Platonic opinion contends that the truth is limited to the crossed thumbs, but for Kentridge the fluctuation between antagonistic realms experienced by the viewer of a shadow is just as illuminating. This fluctuation heightens the sense of mediation congenital to art itself, which renders us "conscious of the precept of 'Always be mediating.'"[26] And the precept is unrestricted. Kentridge continues, "All calls to certainty, whether of political jingoism or of objective knowledge, have an authoritarian origin relying on blindness and coercion—which are fundamentally inimical to what it is to be alive in the world with one's eyes open."[27] Opening our eyes and being alive in the world coincide with giving up one-sidedness. From shadows we learn about our intervention in the creation of both illusions and meanings.[28] It is no longer a matter of holding to the one or the other but rather of setting free the circularity of truth versus untruth. If shadows work in a manner akin to art, it is because they disclose ways of experiencing our own construction of experience. The path to awareness indicated by shadows does not treat vision and knowledge as distinct activities. It uncovers the intertwining of sight and insight, fantasy and thought, feelings and perceptions, that makes up the multidimensional sphere of a consciousness.

Kentridge's attempt to overcome Platonism can be linked with the stance of Friedrich Nietzsche, one of the first Western philosophers to dismantle Plato's dualistic mode of thought. The effect of this dismantling became apparent to Nietzsche in a sudden brainstorm, which he wrote down in 1888: "The true world is gone: which world is left? The illusory one, perhaps? . . . But no! *we got rid of the illusory world along with the true*

one!"[29] Nietzsche perceived that the true and illusory worlds are two sides of the same coin. Getting rid of the true world must doom the other as well. Nietzsche's insight paralleled his meditations on art and artists. Because there are no definite truths, artistic creation is evidence of a will freely willing its own becoming. Maintaining that art intensifies and re-creates existence, Nietzsche could move beyond the two worlds and break the boundaries separating knowledge, creativity, and life itself. In a similar vein, Kentridge ascribes to art the ability to trespass boundaries and enhance experiential fluidity or mindfulness of mediation. Shadows inspire us to question both appearance and reality. Neither the effigy made by Butades nor the transcendence promised by Plato is enough. The schism between appearance and reality may be superseded by the awakening of forms of attentiveness that simultaneously pose and interlock imagination and intellection.

By refuting Platonism through shadowgraphy, the *Porter Series* stirs such attentiveness. Given that the tapestries thematize a world of people on the move, the porters can now be seen as transitional figures not only by virtue of their cinematic postures and their rather indeterminable referential attributes, but also because as shadows they prompt modes of looking and understanding that override assured parameters of truth and illusion. They are likenesses liable to being taken alternatively for perceptions or inventions, or both. The sense of otherness conveyed by the porters cannot be controlled through univocal categorizations. Otherness is revealed as asymmetrical, unconscious, and yet open to dynamics of proximity and intercourse—provided that we acknowledge the active contribution that otherness makes to our being or becoming attentive to the worlds of others as well as to our own introspective worlds. Otherness, that is, is not remotely outside, nor can it be entirely absorbed within. It is a shifting factor construed within a relation that may divert, entangle, and define the emergence of the self and the other. In fact, the concealed elements that qualify the porters' identities may equally qualify the identities of those facing them, because the recognition of others parallels the realization of concealed elements within and outside of oneself. If the geographic maps function as the wall of Plato's cave, if the tapestries' backgrounds are screens for cinematic projections of shadows, then the onlookers (and, initially, the artist himself) oscillate between believing and disbelieving the pictures of the *Porter Series*. Their position comes to correspond to the arena of the unconscious, understood as a mutable place of transmigration in which who one is or becomes is inextricable—perceptively, emotionally, and mentally—from a state of attentiveness to otherness.

The *Porter Series* suggests that a world of people on the move now constitutes the arena in which such encounters with oneself and between oneself and others take place. Though the maps indicate a past moment in human migration, the series attests the predicaments and hopes that characterize life in a postcolonial, globalized world. Just as more and more people are transiting the planet, so are they destined to meditate about unknown horizons of existence and human existence itself. In the world of the *Porter Series*, awareness proceeds from the making of symmetries, albeit mutable, between conscious and unconscious dimensions of life, the genetic fate of

being human and the personal history of one or more individuals. Whereas in Plato and Pliny, shadows validate myths of origins, in the *Porter Series* shadows unsettle any certitude about origins. As silhouettes of people on the move, shadows summon up the repeated self-(re)creations that humans enact in order to continue life within the transindividual sphere of the world. These (re)creations do not answer the metaphysical question about where we are coming from and going to; they do not solve the riddle of the origins of the human species. Nonetheless, they intimate that exodus and migration make the uncertainty of origin something that can be performed throughout the journey. (Re)creating themselves, people reproduce and reiterate each time anew the very uncertainty of the blank slate of human origin, so that the blank itself becomes the object of experience, the experiential fulcrum of a nascence characterized by both the lack of origin (common to the whole species) and the abundance of singularity inherent in every individual.

THE GENUS OF DRAWING

How did Kentridge's work come to rehearse Nietzsche's insight about the collapse of the worlds of truth and illusion? I propose that the answer can be found in the primacy of drawing throughout his artistic production. In his animated films (e.g., *Johannesburg, 2nd Greatest City After Paris* [1989]; *Mine* [1991]; *Felix in Exile* [1994]), for example, "the process of facture remains visible"[30] because the film is constructed by shooting a series of drawings in charcoal and pastel, each repeatedly erased, redrawn, and photographed throughout its metamorphoses (fig. 15). Unlike cel animation, which employs thousands of drawings, Kentridge's films—he pointedly calls them "drawings for projection"—merge moments of a small number of drawings visualizing a scene or sequence. They record the effluence of drawing itself: a springing forth and vanishing of visions, lines, figures, and plots. Kentridge has said, "It is only when physically engaged on a drawing that ideas start to emerge."[31] "Drawing for me is about fluidity. . . . What I'm interested in is a kind of multilayered highway of consciousness. . . . My work is about a process of drawing that tries to find a way through the space between what we know and what we see."[32] Begetting neither realism nor abstraction, drawing outstrips both the true and the illusory world. It is a practice whose unstipulated spectrum warrants its extraordinarily wide reverberations. "In the indeterminacy of drawing," Kentridge comments, "lies some kind of model of how we live our lives. The activity of drawing is a way of trying to understand who we are or how we operate in the world."[33]

Two aspects of Kentridge's understanding of drawing bear special notice here. The first is his apparent intuition of a generic creativity, which drawing announces and sustains by disclosing the multidimensional nature of its applications. By "generic creativity" I mean that the emergence of creative work, as well as the effects it generates, cannot be linked exclusively with specialized areas of competence nor can it be sufficiently explained according to pregiven taxonomies—formal, linguistic, or conceptual. To emphasize the "generic" aspects of cre-

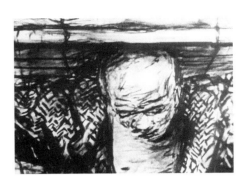

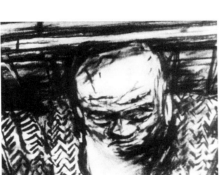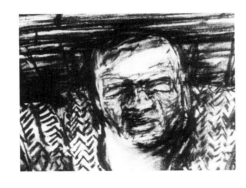

Fig. 15. Stills from William Kentridge's film *Monument*, 1990.
Courtesy of the artist

ativity is to revive the ancient understanding of *tekhnê* as any kind of human capacity to bring something into existence. As a generic human trait, creativity belongs to the very fact of being alive.[34] It acts as a sort of primary agency mediating between heterogeneous reciprocal dimensions of occurrences and experiences.

The second aspect, which may be called "coevolutive coorigination," describes the dynamics of this creative reciprocation, in which seemingly independent realms—such as those of subject and object, individual and signs, energy and matter, seeing and knowing—are revealed as codependent by the very coupling through which they both arise.[35] Kentridge hints at a generic quality of the creative act when he speaks of drawing's indeterminacy and associates drawing with the very way we live our lives. He alludes in turn to a process of coorigination when he indicates the fluid character of drawing and states his interest in a "multilayered highway of consciousness," which I take to be an interest in the many concurrent forces that manifest consciousness as such. Both generic creativity and creative coevolving are key to grasping drawing's capacity to manifest to the senses the extrasensory agencies of the mind and the imagination. Drawing thus becomes a potential model of being and becoming in the world. Touching the dynamics of life itself, drawing for Kentridge names a generic artistic expertise that augments awareness in its visual, emotional, cognitive, and existential components.

Kentridge's understanding of drawing brings us back to a moment before the eighteenth-century foundation

of the beaux-arts system. It echoes the concept of *disegno* elaborated by writers and artists of the Italian Renaissance, from Lorenzo Ghiberti to Giorgio Vasari and Federico Zuccaro. Through the pivotal concept of *disegno*, or drawing, these authors reworked ancient views of *tekhnê* as an all-encompassing activity and of creativity as a generic human faculty. They regarded *disegno* as a matrix that both engendered and surpassed the arts of architecture, painting, and sculpture. By permitting the artist to envision images adaptable to various mediums, drawing formed the practical and theoretical basis for any painting, sculpture, or other work of art and thus legitimated for the first time their intellectual worth as products of liberal arts. Vasari, blending Plato and Aristotle, equated *disegno* with idea, meaning that drawing produces not so much representations of a preexisting reality but events of consciousness that are lived and reified in the signs jotted down on a sheet.[36] Michelangelo contended that there is only one art or science—drawing or painting—because "if one considers well all that is done in this life, one will find that everybody unconsciously is engaged in painting this world."[37] Through the concept of *disegno*, Renaissance authors placed art and knowledge on equal footing, appreciating creativity as lived experience guided by mutual transmigrations of subjects and objects, images and existence. *Disegno*, that is, repeatedly reprises the archetypical nexus between the inventive enactment of a technical and artistic know-how and the process of becoming human.[38] *Disegno* demonstrates that this nexus is not unidirectional. Rather it signifies a coevolutive correlation between individuals and environment, artificial and natural things. In a period before the calcification of the modern beaux-arts system, *disegno* nourished the intuition of a generic creativity whose universal bearing not only explores unlimited avenues of co-origination, but is also evidence of a multidimensional "extra" that escapes the categories of the arts, which *disegno* nevertheless helped to define.

The affinities between Renaissance *disegno* and Kentridge's understanding of drawing immunize his works against the strains of the beaux-arts system and its corollary discrimination between art and craft. Once grasped in its generality, *disegno* thwarts rigid classification of artistic phenomena in terms of production and reception focused on the characteristics of distinct mediums. It would be reductive to appreciate a work of art only according to the values it attaches to a specific material, its aesthetic stimulation of a specific sensory organ, or its endorsement and/or transformation of an art-historical sequence

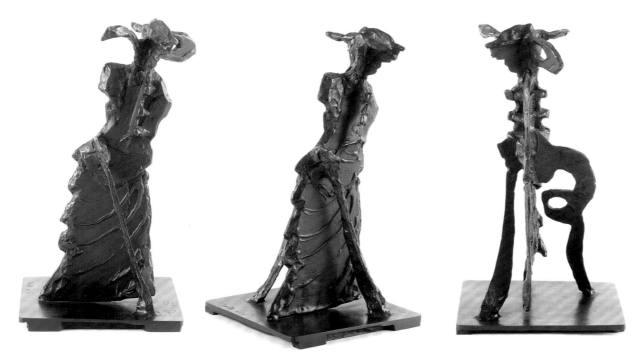

Fig. 16. William Kentridge, three views of the same female figure from *Promenade II* (plate 4). Courtesy of the artist

based upon an ascertained artistic form. Tellingly, Kentridge pursues various practices—film, video, printmaking, theater, sculpture—in which the sense of drawing as a virtually all-encompassing activity is valued both for the imagery it breeds and for the freedom it grants him in experimenting with diverse materials. For instance, when Kentridge produces works in bronze, thus linking himself with an ancient form of representation laden with art-historical overtones, the outcome is a work that conflates time-honored attributes of sculpture, such as tactility and mass, with the fleeting qualities of cinematic vision. Kentridge's bronze figures may look surprisingly flat—like hefty imprints of a film or sheet of paper—and quite different depending on the angle from which one views them (fig. 16). This loosening of the boundaries among preordained uses and applications of sculpture and cinema makes the images refer back and forth to the harmonic, multidimensional space of drawing. It suggests that a work of art's raison d'être should be sought over and above any coded system of the arts, if not over and above whatever mediums have been or can be devised by artists in the making of a work.

Kentridge's works do not seek to further particular privileged practices or artistic traditions, nor are they simply about inventing new mediums.[39] Informed by the "indeterminacy" of drawing, Kentridge's practice correlates images, physical supports, and dimensions of life in ways that preserve and bolster the intuition of a generic creativity. In the *Porter Series*, the woven images are not so much a revaluation of the "craft" or "art" properties of tapestry as an intensification of its bond with the pervasive agency connatural to the experience of drawing. Along with thematizing issues of transnational citizenship, frustrating judgments of taste attached to tapestry, and confounding dualistic assumptions of appearance and reality, the *Porter Series* explores generic creativity in its artistic and non-artistic implications. Thus, another course of associations is triggered by the *Porter Series*—this time bringing us full circle.

PATHS LAID DOWN IN WALKING

The *Porter Series* restores to tapestry the dignity it enjoyed before the divide between art and craft, without complying with the demands of eminent patrons or magnifying religious and historical traditions. Produced for the free global market of contemporary art, Kentridge's tapestries celebrate nameless constituents of humanity. They present images of anonymous people whose lives are divorced from the affairs of national geopolitics and indiscernible from the viewpoint of a seemingly mandatory course of world history. The nomadism of the porters resonates with the nomadic nature of tapestry itself—which is an extremely portable artwork: it can be easily rolled and carried, thus offering a way of making and using images that are suitable to conditions of both traveling and dwelling.[40] Once all this is clear, it is likewise apparent that Kentridge's tapestries do not merely seek to elicit disinterested responses and rankings of formal achievement. Furthermore, the multiple meanings of the porters' identities, the transits they epitomize, the cinematic effect of their postures, and their shadowy lack of substance

can all be seen as evoking Kentridge's experience of drawing. The *Porter Series* actualizes this experience because the movement across different dimensions and the metamorphoses it generates pertain to the porters as well as to the viewers of the tapestries and to the artist himself. In various degrees, one may partake of the sense of indeterminacy that Kentridge ascribes to the activity of drawing while linking it with "how we live our lives." As shadows of bodies absolved from spatiotemporal coordinates, and through the narratives of travel and migration that they conjure, the porters exemplify indeterminacy both visually and thematically. It is a matter of recognizing otherness—the porters, the shadows, the maps, the image itself—as affecting what happens to viewers vis-à-vis the woven pictures. For the artist, it is a matter of interposing images and experience, vision and intellection, within a production where the forms of life and the forms of art coevolve, sharing both arbitrariness of rules and uncertainty of origins.

All this suggests that after globalization, in the world that the *Porter Series* anticipates, artists have the same destiny as everybody else on the move. A world of human transits implies the mobilization of absolutely generic human traits such as creativity and language. These traits provide resources for exchange, struggle, and transformations among different cultures. Generic creativity is the trait that characterizes the moving porters, who, whether travelers, exiles, migrants, or workers, must be not only flexible in channeling the unmitigated forces of their bodies and minds, but also ready to reactivate continuously the conditions of their own coming into existence as human beings.[41] This reactivation guarantees them opportunities of proximity, confrontation, and survival within the planetary sphere. Similarly, artists' contributions cannot be merely knowledgeable additions to the internal histories of particular arts, nor to the introduction of new mediums. In a world of people on the move, an artist must always stand ready to correlate signs and events, unrestricted introspectiveness and situated energies. These correlations depend not so much on expertise rooted within specialized traditions as on deepening the generic expertise of creativity. Generic creativity is a resource that an artist can rely upon and expand whenever a radical restaging of received procedures and means of expression is felt necessary for cultural, ethical, and political reasons. Responding to the challenges and promises of a globalized planet, Kentridge effects this restaging by making the experience of drawing the beacon of his practice.

A know-how that is both generic and unconfined, drawing expands into productions in which the process does not disappear but rather is made public within the product. This is probably why Kentridge, emulating the attitudes and deceptions of the pioneering film director Georges Méliès (1861–1938), in *Journey to the Moon* (2003) films himself in his studio while walking, stalking the drawings, making and erasing forms, grabbing flying pages and scrutinizing them, lifting a chair as if by magic, discovering what one sees using a coffee cup as a monocle, being followed by a woman invisible to him in the flesh but previously spotted in her sketched likeness in a book (fig. 17). The filming of these performances illustrates Kentridge's modus operandi: a first-person event

Fig. 17. Stills from William Kentridge's film *Journey to the Moon*, 2003. Courtesy of the artist

enveloping all those dynamics—conscious and unconscious, imaginary and perceptive—by which images come into existence through embodied experience. But there is more. Like the porters in the tapestries, Kentridge walks in his studio, infringing spatiotemporal boundaries. His transits through dimensions, like those of the porters, are unpredictable in that they occasion moments of fracture, mediation, and contact among states of being and becoming unknown beforehand but identifiable precisely within the transiting. Both porters and artists share a disposition to strike paths that exist only as they are laid down in walking.[42] These paths objectify the multidimensional "extra" of generic creativity while designing trajectories of awareness.

The *Porter Series* proposes that becoming aware in a world of people on the move is a process that flows from the coevolutive couplings of vision and knowledge, imagination and thought, emotion and intellect. Just as a confrontation with the enigmatic power of shadows may result in a mindfulness of mediation, so a confrontation with the destabilizing realization of otherness may turn into encounters with oneself and between oneself and others. The concealed elements inherent to human beings on the move ultimately characterize not only migration and interaction among individuals or groups, but also introspection and creation. In different but concurrent modes, these elements animate attentiveness and project a consciousness into the unconscious. Experiencing the world not as a datum that can be codified in subjective or objective terms but as the fabric of dependent coorigination between deeds and doers, people and environments, consciousness discovers itself groundless and yet intimately intermeshed with the dramas, inequalities, and aspirations of the world. Enhancing experiential fluidity, the *Porter Series* vindicates for artistic practice the job of reifying into images this discovery, which is so crucial for the forms of life arising after the collapse of the true and illusory worlds.

1. Surveys of the history of tapestry making include Pierre Verlet, Michel Florisoone, Adolf Hoffmeister, and François Tabard, *The Book of Tapestry: History and Technique* (New York: Vendome Press, 1978); Madeleine Jarry, *World Tapestry, from Its Origins to the Present* (New York: Putnam, 1969); Wolfgang Brassat, *Tapisserien und Politik: Funkionen, Kontexte und Reception eines repräsentativen Mediums* (Berlin: Mann, 1992); Barty Phillips, *Tapestry* (London: Phaidon, 1994).

2. Out of the vast literature on the subject, see John Shearman, *Raphael's Cartoons in the Collection of Her Majesty the Queen, and the Tapestries for the Sistine Chapel* (London: Phaidon, 1972); Creighton Gilbert, "Are the Ten Tapestries a Complete Series or a Fragment?" in *Studi su Raffaello*, ed. Micaela Sambucco Hamoud and Maria Letizia Strocchi (Urbino: QuattroVenti, 1987), vol. 1, pp. 533–50; Sharon Fermor, *The Raphael Tapestry Cartoons: Narrative, Decoration, Design* (London: Scala Books, 1996); Thomas P. Campbell, "The Acts of the Apostles Tapestries and Raphael's Cartoons," in Campbell, *Tapestry in the Renaissance: Art and Magnificence*, exh. cat. (New York: The Metropolitan Museum of Art; New Haven: Yale University Press, 2002), pp. 187–203.

3. The set consists of twelve panels, seven of which, based upon sketches by Rubens, were given in 1625 by Louis XIII to Cardinal Francesco Barberini. Barberini had been sent to Paris by his uncle Urban VIII as papal legate to negotiate with the king over the Valtelline controversy. Back in Rome, Barberini decided to complete the set with panels woven from designs by Pietro da Cortona and finished in 1630. See David Dubon, *Tapestries from the Samuel H. Kress Collections at the Philadelphia Museum of Art: The History of Constantine the Great Designed by Peter Paul Rubens and Pietro da Cortona* (London: Phaidon, 1964).

4. For modern and contemporary attempts to redress the balance between artists and weavers and revaluate tapestry's worth, see Hoffmeister's essay in *The Book of Tapestry*, pp. 116–36; and Phillips, *Tapestry*, pp. 117–68. See also Jean Lurçat, *Tapisserie Française* (Paris: Bordas, 1947). Fresh light on the significance of tapestry was also cast by Aloïs Riegl in his studies of textile art, especially the paradigmatic *Stilfragen: Grundlegungen zu einer Geschichte der Ornamentik* (Berlin: G. Siemens, 1893), in which he boldly claimed a continuity of a few fundamental motifs (i.e., the palmette, the zigzag, the rosette) in the history of ornament from ancient Egypt to modern times. Finally, it is noteworthy that Le Corbusier, in *Tapisseries éxécutées dans l'atelier Tabard à Aubusson* (Paris: Galerie Louise Réné, 1952), n.p., called for a renewal of tapestry understood as "muralnomad," arguing that "today's tapestry is and will be the mural of the nomad. The painted mural one rolls under one's arm. We are all nomads, living in rented apartments and in future Unités d'Habitation." For the whole point, see Romy Golan, "From

Monument to *Muralnomad*: The Mural in Modern European Architecture," in *The Built Surface*, vol. 2, *Architecture and the Pictorial Arts from Romanticism to the 21st Century*, ed. Christy Andweson and Karen Koehler (London: Ashgate, 2002), pp. 201–5.

5. For the new, "artistic" status of the images in the Renaissance, see Hans Belting, *Likeness and Presence: A History of the Image before the Era of Art*, trans. Edmund Jephcott (Chicago: University of Chicago Press, 1994), especially pp. 470–78.

6. On this paradigmatic turn, heralded in works such as Charles Batteux's *Les beaux arts réduits à un même principle* (1746) and Immanuel Kant's *Kritik der Urteilskraft* (1790), see Paul Oskar Kristeller, "The Modern System of the Arts" (1951–52), reprinted in Kristeller, *Renaissance Thought II: Papers on Humanism and the Arts* (New York: Harper and Row, 1965), pp. 163–227; Larry Shiner, *The Invention of Art: A Cultural History* (Chicago: University of Chicago Press, 2001).

7. The ancient Sanskrit root *kr*– or words like the Vedic *śilpa*, the Greek *tekhnê*, and the Latin *ars* allude to a general human ability to know how to do, make, perform, and create in a variety of more or less specialized activities. For the gap between ancient and modern conceptions of "artistic" activity, see Kristeller, "The Modern System of the Arts"; Shiner, *The Invention of Art*. See also Lionello Venturi, "Per il nome di arte" (1929), reprinted in *Saggi di critica* (Rome: Bocca, 1956), pp. 121–28; Tullio De Mauro, "Per la storia di *Ars* 'Arte'," *Studi Mediolatini e Volgari*, vol. 8 (Bologna: Libreria Antiquaria Palmaverde, 1960), pp. 53–68. Martin Heidegger, in *Nietzsche* (1961), trans. David Farrell Krell (New York: HarperCollins, 1991), vols. 1–2, pp. 80–82, made insightful comments on *tekhnê* as a knowledge inspiring any sort of human endeavor to bring forth something in the midst of beings. On the gradual conflating of the concepts of *tekhnê*, poiesis, and creativity in Greek thought, see Cornelius Castoriadis, "Technique," in *Les carrefours du labyrinthe 1* (Paris: Seuil, 1978), pp. 289–95.

8. I will say more about Renaissance *disegno* in the fourth section, where I discuss Kentridge's own experience of drawing.

9. Gerald Reitlinger, *The Economics of Taste*, vol. 2, *The Rise and Fall of Objets d'Art Prices since 1750* (London: Barrie and Rockliff, 1963), pp. 68–69, relates that, in 1778, a late-fifteenth-century Arras or Tournai tapestry, until then at the Old Somerset House, went on sale at a remarkably low price. A few years later, the Cathedral Chapter of Angers failed to sell the fourteenth-century *Apocalypse* designed by Jan Boudolf and woven in Robert Poinçon's workshop—now among the most admired tapestries in the West.

10. Eugène Müntz, one of the first art historians to trace tapestry's history, commended it as "an essentially sumptuous art . . . intended to charm, captivate, and dazzle far more than to move or instruct.

It is not its vocation to depict suffering or abnegation, austerity or high philosophical conceptions." Müntz, *A Short History of Tapestry: From the Earliest Times to the End of the Eighteenth Century*, trans. Louisa J. Davis (London: Cassell, 1885), pp. xiv–xv.

11. On Kentridge's work, see Carolyn Christov-Bakargiev, *William Kentridge*, exh. cat. (Brussels: Société des Expositions des Beaux-Arts, 1998); Dan Cameron, Carolyn Christov-Bakargiev, and J. M. Coetzee, *William Kentridge* (London: Phaidon, 1999); Rosalind Krauss, "'The Rock': William Kentridge's Drawings for Projection," *October* 92 (Spring 2000), pp. 3–35; Neal Benezra et al., *William Kentridge*, exh. cat. (New York: Harry N. Abrams in association with Museum of Contemporary Art, Chicago, and New Museum of Contemporary Art, New York, 2001); Carolyn Christov-Bakargiev, ed., *William Kentridge*, exh. cat., Castello di Rivoli, Museo d'Arte Contemporanea (Milan: Skira, 2004).

12. See Patrick Manning, *Migration in World History* (New York: Routledge, 2005), which also contains valuable bibliographies for specific periods, groups, and countries.

13. Studies on African migrations and slavery include Isidore Okpewho, Carole Boyce Davies, and Ali A. Mazrui, eds., *The African Diaspora: African Origins and New World Identities* (Bloomington: Indiana University Press, 1999); Paul E. Lovejoy and David V. Trotman, eds., *Trans-Atlantic Dimensions of Ethnicity in the African Diaspora* (London: Continuum, 2003). For the global implications of slavery in modernity, see also Patrick Manning, *Slavery and African Life: Occidental, Oriental, and African Slave Trades* (Cambridge: Cambridge University Press, 1990).

14. For cinema's characteristic condensation of motion and emotion, and its link with travel culture, see Giuliana Bruno, *Atlas of Emotion: Journeys in Art, Architecture, and Film* (New York: Verso, 2002).

15. For the inhuman condition of the globally excluded who have been denied citizenship, see Giorgio Agamben, *Homo Sacer: Sovereign Power and Bare Life*, trans. Daniel Heller-Roazen (Stanford: Stanford University Press, 1998).

16. With regard to East and Southeast Asian countries, Aihwa Ong argues that neoliberalism favors an interactive mode of social organization based on marketable skills rather than state citizenship; see Ong, *Neoliberalism as Exception: Mutations in Citizenship and Sovereignty* (Durham: Duke University Press, 2006).

17. For Mary Louise Pratt, "contact zone" names the shifting spaces of colonial encounters and struggles; see Pratt, *Imperial Eyes: Travel Writing and Transculturation* (London: Routledge, 1992), pp. 4–7. See also James Clifford, *Routes: Travel and Translation in the Late Twentieth Century* (Cambridge, Mass.: Harvard University Press, 1997), pp. 188ff.; and Clifford's 1999 interview with Alex Coles in

Clifford, *On the Edges of Anthropology* (Chicago: Prickly Paradigm Press, 2003), pp. 33–35.

18. For the ways in which difference and hybridization affect people living at the borders of heterogeneous cultures, see Homi K. Bhabha, *The Location of Culture* (1994; reprint, London: Routledge, 2004). The encounter with others as recognition/preservation of their being as they are in their opaqueness is at the core of Édouard Glissant's meditations on the cultures borne out of creolization; see his *Poetics of Relation*, trans. Betsy Wing (Ann Arbor: University of Michigan Press, 1997). "Rhizoma" and "rhizomatic" are key in Gilles Deleuze and Félix Guattari's thinking about the processes intertwining organic and inorganic forces; see Deleuze and Guattari, *Rhizome (Introduction)* (Paris: Éditions de Minuit, 1976); idem., *A Thousand Plateaus: Capitalism and Schizophrenia*, trans. Brian Massumi (Minneapolis: University of Minnesota Press, 1987). For "ethnoscape" as the transnational landscape of tourists, immigrants, refugees, and guest workers, see Arjun Appadurai, *Modernity at Large: Cultural Dimensions of Globalization* (1996; reprint, Minneapolis: University of Minnesota Press, 2005), especially pp. 33–34.

19. Western colonizing views of other civilizations were exposed by Edward Said's 1978 classic *Orientalism: Western Representations of the Orient* (Harmondsworth U.K.: Penguin, 1985). For the risks run, for instance, by contemporary African artists acting or being fashioned as "others," see Olu Oguibe and Okwui Enwezor, eds., *Reading the Contemporary: African Art from Theory to the Marketplace* (Cambridge, Mass.: MIT Press, 1999); Olu Oguibe, *The Culture Game* (Minneapolis: University of Minnesota Press, 2004).

20. Inexplicable within predefined categories of class, citizenship, gender, and work, the porters would thus stand for political subjects variously postulated by Italian *operaismo* and postcolonial Indian historiography. See, for instance, Mario Tronti, *Operai e capitale* (1966; reprint, Rome: DeriveApprodi, 2006); Michael Hardt and Antonio Negri, *Empire* (Cambridge, Mass.: Harvard University Press, 2000); Paolo Virno, *A Grammar of the Multitude*, trans. Isabella Bertoletti, James Cascaito, and Andrea Casson (Cambridge, Mass.: Semiotext(e), 2004); Gayatri Chakravorty Spivak, "Can the Subaltern Speak?" in *Marxism and the Interpretation of Culture*, ed. Carl Nelson and Lawrence Grossberg (Urbana: University of Illinois Press, 1988), pp. 271–313; Dipesh Chakrabarty, "Subaltern Histories and Post-Enlightenment Rationalism" (1995), reprinted in *Habitations of Modernity: Essays in the Wake of Subaltern Studies* (Chicago: University of Chicago Press, 2002), pp. 20–37.

21. For shadows as souls or parts of someone's self, see James G. Fraser's *The Golden Bough* (1922; reprint, New York: Touchstone, 1996), pp. 220–22. For shadows in the visual arts, see Ernst H. Gombrich, *Shadows: The Depiction of Cast Shadows in Western Art*

(London: National Gallery, 1995); Michael Baxandall, *Shadows and Enlightment* (New Haven: Yale University Press, 1995); and Victor I. Stoichita's manifold study, *A Short History of Shadows*, trans. Anne-Marie Glasheen (London: Reaktion Books, 1997). For shadows' continuing appeal in art, culture, science, and religion, see Max Milner, *L'Envers du visible: Essai sur l'ombre* (Paris: Éditions du Seuil, 2005).

22. *Lettres de Paul Gauguin à Émile Bernard, 1888–1891* (Geneva: Pierre Cailler, 1954), pp. 63–64. For Gauguin's statement, its context, and the work of other contemporary painters depicting the shadow alone, see Nancy Forgione, "'The Shadow Only': Shadow and Silhouette in Late Nineteenth-Century Paris," *Art Bulletin* 81, no. 3 (September 1999), pp. 490–512. See also Gombrich, *Shadows*, p. 55.

23. William Henry Fox Talbot, one of its inventors, called photography "the art of fixing a shadow"; see his "Some Account of the Art of Photogenic Drawing . . . " (1839), reprinted in *Photography: Essays and Images; Illustrated Readings in the History of Photography*, ed. Beaumont Newhall (New York: Museum of Modern Art, 1980), p. 25.

24. For phantasmagoria, see Martin Quigley, *Magic Shadows: The Story of the Origin of Motion Pictures* (Washington, D.C.: Georgetown University Press, 1948), pp. 75–79; Jonathan Crary, *Techniques of the Observer: On Vision and Modernity in the Nineteenth Century* (Cambridge, Mass.: MIT Press, 1990), pp. 132–36; Terry Castle, *The Female Thermometer: Eighteenth-Century Culture and the Invention of the Uncanny* (New York: Oxford University Press, 1995), especially chap. 9; Bruno, *Atlas of Emotion*, p. 146.

25. Quoted from Kentridge's 2001 lecture, "In Praise of Shadows," in *William Kentridge*, ed. Christov-Bakargiev (2004), p. 159. In linking cinema with Plato's cave, Kentridge endorses an oft-made point in cinema studies. See, for instance, Jean-Louis Baudry, "The Apparatus: Metapsychological Approaches to the Impression of Reality in the Cinema," in *Narrative, Apparatus, Ideology: A Film Theory Reader*, ed. Philip Rosen (New York: Columbia University Press, 1986), pp. 299–318.

26. Kentridge, "In Praise of Shadows," p. 159.

27. Ibid., p. 161.

28. As Kentridge remarks: "The child who plays with shadows delights not just in seeing the image of a creature on the wall, but also in watching and grasping the illusion, in learning how shadows of hands can be transformed into animals. This awareness of how we construct meaning, and this inescapable need to make sense of shapes, seems to me very central, indeed essential, to what it means to be alive—to live in the world with open eyes." See William

Kentridge, "Black Box: Between the Lens and the Eyepiece," in *William Kentridge: Black Box / Chambre Noire*, exh. cat. (Berlin: Deutsche Guggenheim, 2006), p. 47.

29. Friedrich Nietzsche, "Twilight of the Idols, or How to Philosophize with a Hammer," in *The Anti-Christ, Ecce Homo, Twilight of the Idols, and Other Writings*, ed. Aaron Ridley and Judith Norman, trans. Judith Norman (Cambridge: Cambridge University Press, 2005), p. 171 (emphasis in original). Although I cannot expound on the point here, it is noteworthy that shadows inspired Nietzsche's thought, as with "The Wanderer and His Shadow" (1880), which constituted the second part of *Human, All Too Human* (1886).

30. Christov-Bakargiev, ed., *William Kentridge* (1998), p. 12.

31. William Kentridge, "Mine" (1991), reprinted in Christov-Bakargiev, ed., *William Kentridge* (1998), p. 68.

32. Kentridge, interview with Christov-Bakargiev, in Cameron, Christov-Bakargiev, and Coetzee, *William Kentridge*, pp. 8, 30, 33.

33. Ibid., p. 35.

34. This was clearly perceived by psychoanalyst Donald W. Winnicott, who claimed that creativity "belongs to being alive. It belongs to the aliveness of some animals as well as of human beings." For Winnicott, "The creative impulse is therefore something that can be looked at as a thing in itself, something that of course is necessary if an artist is to produce a work of art, but also something that is present when anyone—baby, child, adolescent, adult, old man or woman—looks in a healthy way at anything or does anything deliberately." See Winnicott, "Creativity and Its Origins," in *Playing and Reality* (1971; reprint, Philadelphia: Brunner-Routledge, 2001), pp. 67–68, 69 (emphasis in original).

35. On the dynamics of coorigination, codependance, and co-arising as pivotal in overcoming dualistic models of knowledge and experience, see Francisco J. Varela, Evan Thompson, and Eleonor Rosch, *The Embodied Mind: Cognitive Science and Human Experience* (Cambridge, Mass.: MIT Press, 1991).

36. See Vasari's definition of *disegno* in the general introduction to the 1568 edition of the *Vite*. Giorgio Vasari, *Le Vite de' più eccellenti pittori, scultori ed architettettori: Nelle redazioni del 1550 e 1568*, ed. Rosanna Bettarini (Florence: Sansoni, 1966), vol. I, p. III.

37. Francisco de Hollanda, "Diálogos em Roma" (1538), reprinted in *Conversations on Art with Michelangelo Buonarroti*, ed. Grazia Dolores Folliero-Metz (Heidelberg: Universitätsverlag C. Winter, 1998), p. 93. Hollanda's reliability has been called into question. For these doubts and the view that the Diálogos are trustworthy whenever consistent with later writers on Michelangelo, such as Vasari, Condivi, and Danti, who didn't know the Diálogos and reported the

artist's own ideas, see David Summers, *Michelangelo and the Language of Art* (Princeton: Princeton University Press, 1981), pp. 26–27, 466 n. 60. For a discussion of Michelangelo on the universality of *disegno*, see ibid., pp. 257–61.

38. André Leroi-Gourhan investigated the nexus between technique and hominization in prehistory in *Geste et la parole* (1964–65), published in English as *Gesture and Speech*, trans. Anna Bostok Berger (Cambridge, Mass.: MIT Press, 1993.) For the "invention of man" as coequal with technical inventions, see also Bernard Stiegler, *La technique et le temps. I. La Faute d'Épiméthée* (Paris: Galilée, 1994), especially pp. 145–87.

39. Rosalind Krauss credits Kentridge's "drawings for projection" with inventing another medium by opening a gap with film and stressing the specificity of "a type of drawing . . . extremely reflexive about its own condition." Krauss, "'The Rock,'" p. 10. Inspired by Stanley Cavell's attempt to redeem the idea of medium from its attachment to the physical bases of various arts and think of it in terms of automatisms or artistic discoveries of conventions, genres, and techniques—see Cavell's "Automatism" in *The World Viewed: Reflections on the Ontology of Film* (Cambridge, Mass.: Harvard University Press, 1979), pp. 101–8—Krauss's argument overlooks the sense of generic creativity conveyed by Kentridge's understanding of drawing.

40. As Le Corbusier proposed, tapestry is the "muralnomad" of the future. See note 4 above, and especially Golan's comments in "From Monument to *Muralnomad*." The idea of a "portable" work of art intrigued twentieth-century artists, as in the paradigmatic case of Marcel Duchamp's several versions of *Box in a Valise* of 1935–41, one of which is now in the Museum of Modern Art in New York, but it may also be traced back to medieval and early modern artefacts such as reliquaries, traveling icons, illuminated books of hours, and portrait miniatures.

41. For "anthropogenesis," or the recreation of one's own origin, referring not to historical crises but to ordinary experience in contemporary societies and organizations of labor, where human nature must explicate its own conditions of possibility, see Paolo Virno, *Quando il verbo si fa carne: Linguaggio e natura umana* (Turin: Bollati Boringhieri, 2003), pp. 75–88.

42. The idea of these paths existing only as they are laid down in walking as well as the possibility of a mindful experience of our own mental life or consciousness were at the core of Francisco Varela's paradigmatic attempt to bridge the gaps among cognitive sciences, Buddhist meditative psychology, and philosophical traditions of phenomenology. See, among others, Varela, Thompson, and Rosch, *The Embodied Mind*; Natalie Depraz, Francisco J. Varela, and Pierre Vermersh, *On Becoming Aware: A Pragmatics of Experiencing* (Amsterdam: John Benjamins, 2003).

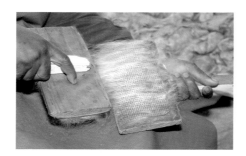

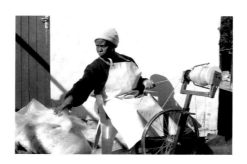

PLATE 17

Office Love, 2001

Tapestry weave with embroidery. Warp: polyester. Weft and embroidery: mohair, acrylic, and polyester
135⁷⁄₁₆ x 179½ inches (344 x 455.9 cm)
Woven by the Stephens Tapestry Studio
1st artist's proof (of 2)
Philadelphia Museum of Art. Purchased with funds contributed by the members of the Committee on
Modern and Contemporary Art, 2006-137-1

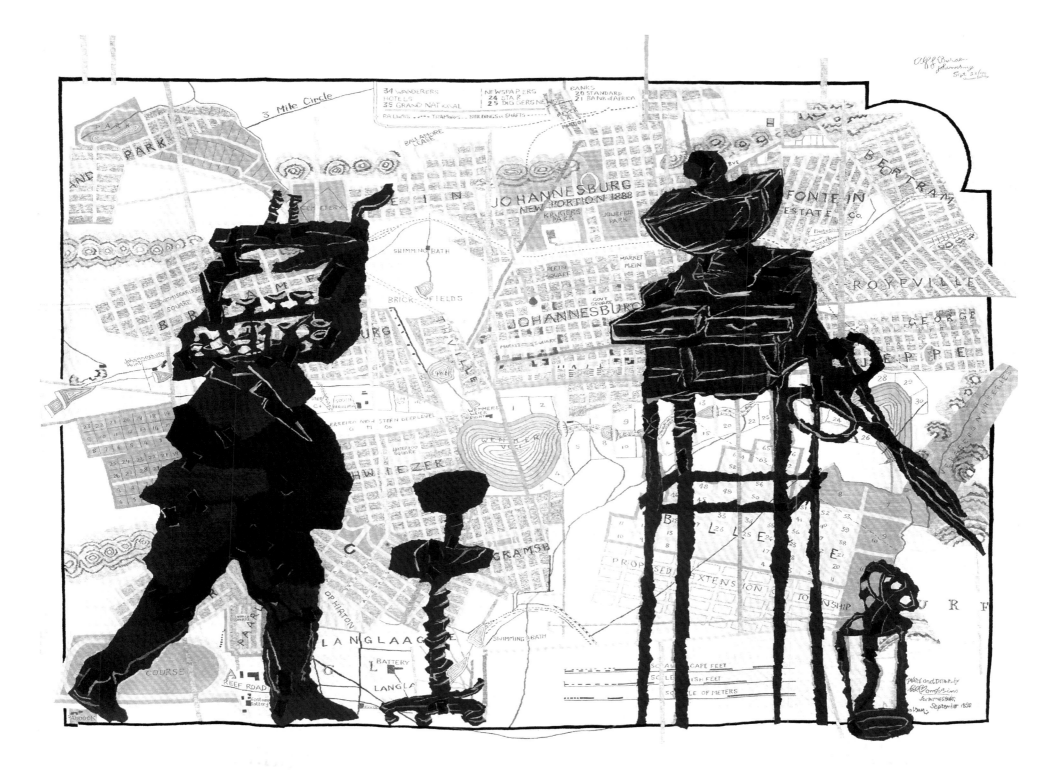

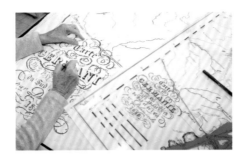

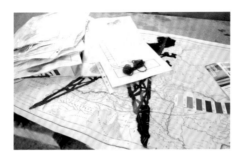

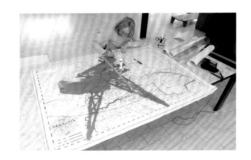

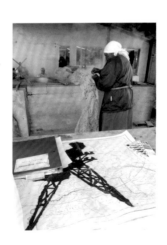

PLATE 18

Porter Series: Germanie et des pays adjacents du sud et de l'est (Pylon Lady), 2006

Tapestry weave with embroidery. Warp: polyester. Weft and embroidery: mohair, acrylic, and polyester
102¾ x 134½ inches (261 x 341.6 cm)
Woven by the Stephens Tapestry Studio
Edition: 1/5
Collection of Massimo d'Alessandro, Rome

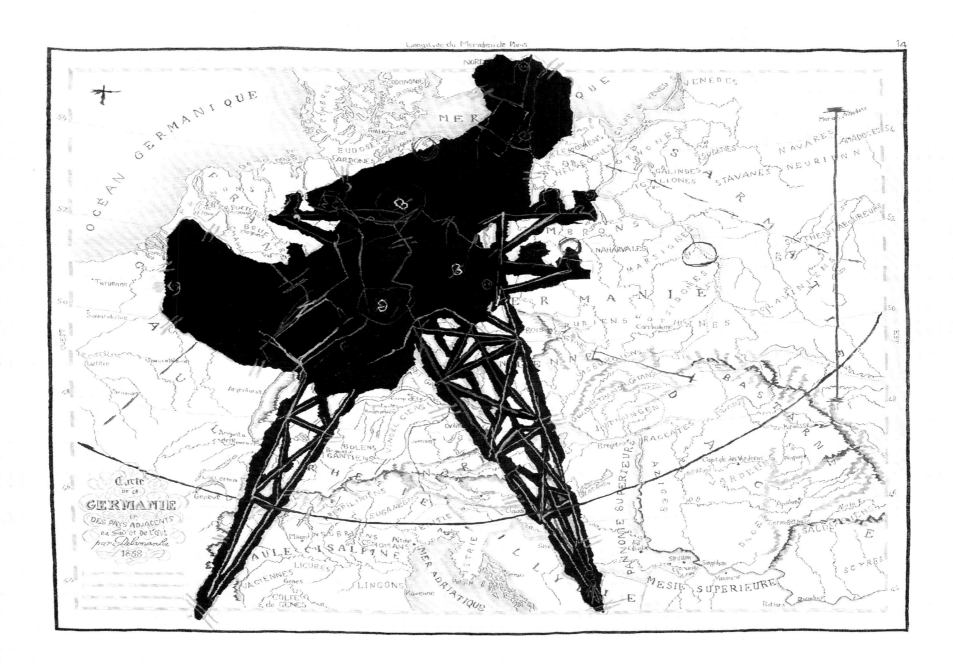

PLATE 19
Porter Series: France divisée en ses 32 provinces (Shower Man), 2006

Tapestry weave with embroidery. Warp: polyester. Weft and embroidery: mohair, acrylic, and polyester
97⅝ x 134½ inches (248 x 341.6 cm)
Woven by the Stephens Tapestry Studio
Edition: 1/5
Collection of Leo and Pearl-Lynn Katz, Bogotá, Colombia

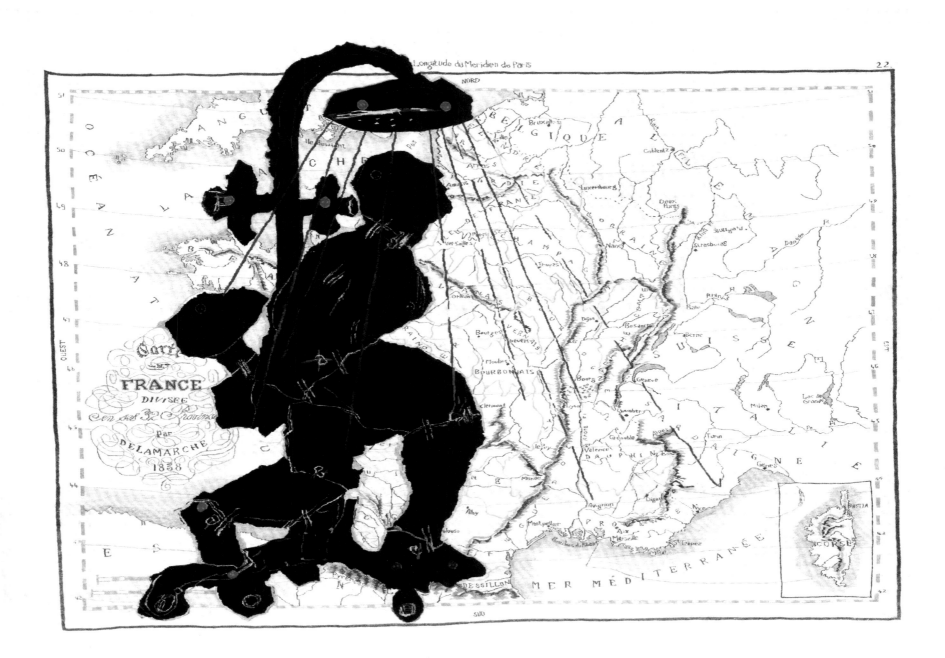

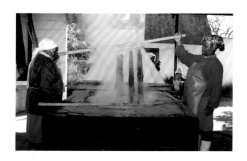

PLATE 20
Porter Series: Egypte, 2006

Tapestry weave with embroidery. Warp: polyester. Weft and embroidery: mohair, acrylic, and polyester
99½ x 134 inches (252.7 x 340.4 cm)
Woven by the Stephens Tapestry Studio
1st artist's proof (of 2)
Courtesy of Lia Rumma Gallery, Milan

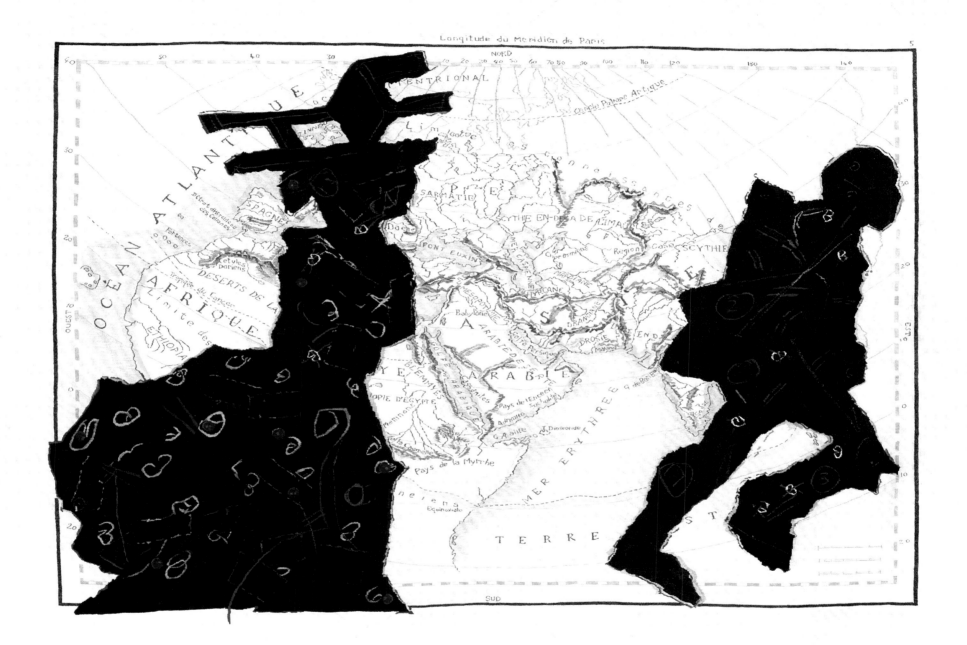

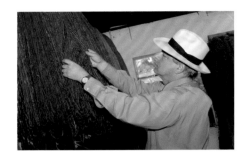

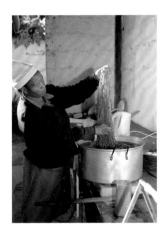

PLATE 21

Porter Series: Amérique septentrionale (Bundle on Back), 2007

Tapestry weave with embroidery. Warp: polyester. Weft and embroidery: mohair, acrylic, silk, and polyester
122⁷⁄₁₆ x 90¹⁵⁄₁₆ inches (311 x 231 cm)
Woven by the Stephens Tapestry Studio
Edition: 1/5
Collection of Isabel and Agustín Coppel, Mexico City

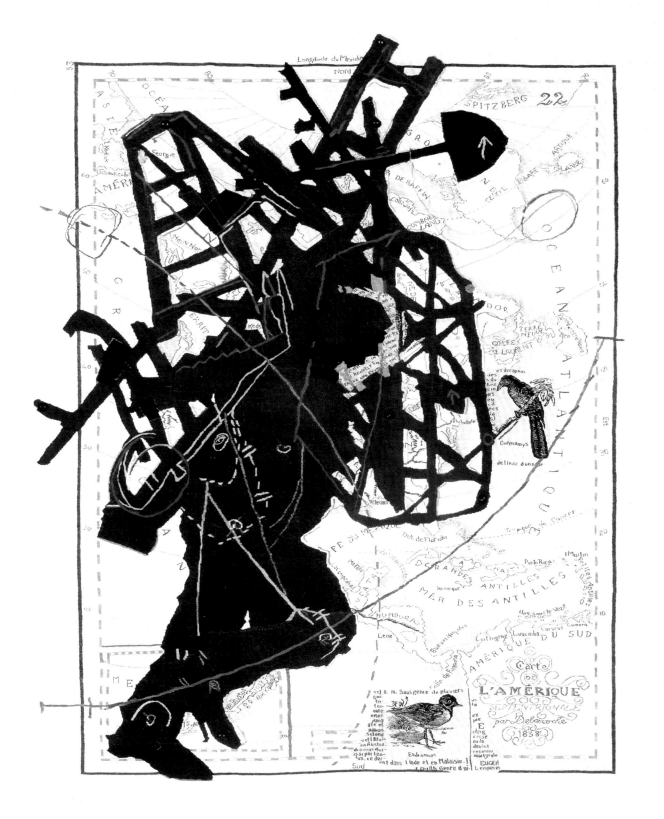

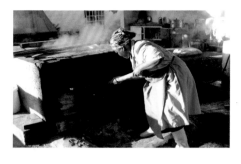

PLATE 22
Porter Series: Norwège, Suède et Danemark (Porter with Chairs), 2005

Tapestry weave with embroidery. Warp: polyester. Weft and embroidery: mohair, acrylic, and polyester
108 x 78 inches (274.3 x 198.1 cm)
Woven by the Stephens Tapestry Studio
1st artist's proof (of 2)
Private collection

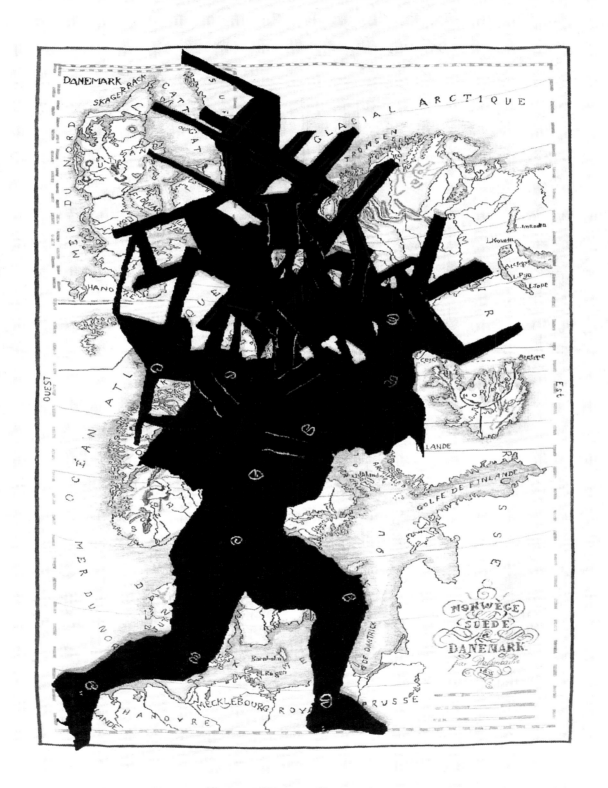

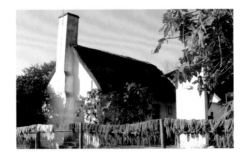
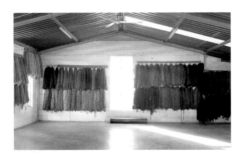
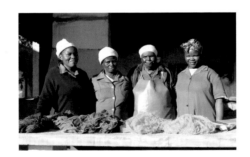

PLATE 23
Porter Series: Russie d'Europe (Man with Bed on Back), 2007
Tapestry weave with embroidery. Warp: polyester. Weft and embroidery: mohair, acrylic, and polyester
123 x 90¾ inches (312.4 x 230.5 cm)
Woven by the Stephens Tapestry Studio
1st artist's proof (of 2)
Private collection

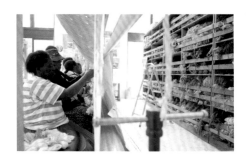

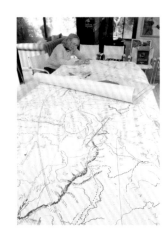

Porter Series: Espagne et Portugal (Porter with Bicycle), 2004

Tapestry weave with embroidery. Warp: polyester. Weft and embroidery: mohair, acrylic, and polyester
98¾ x 130½ inches (250.8 x 331.5 cm)
Woven by the Stephens Tapestry Studio
1st artist's proof (of 2)
Private collection

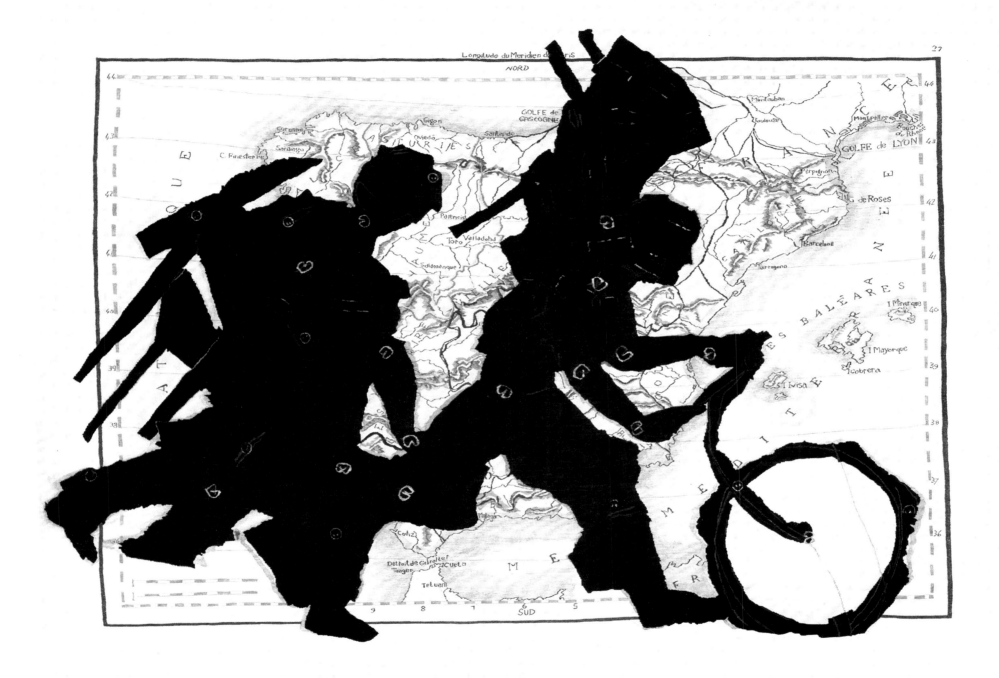

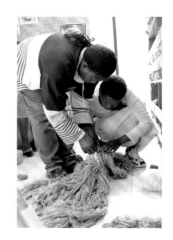

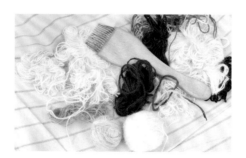

PLATE 25
Porter Series: Asie Mineure (Tree Man), 2006

Tapestry weave with embroidery. Warp: polyester. Weft and embroidery: mohair, acrylic, and polyester
97⅝ x 135⅛ inches (248 x 343.2 cm)
Woven by the Stephens Tapestry Studio
Edition: 1/5
D'Amato Collection, Naples

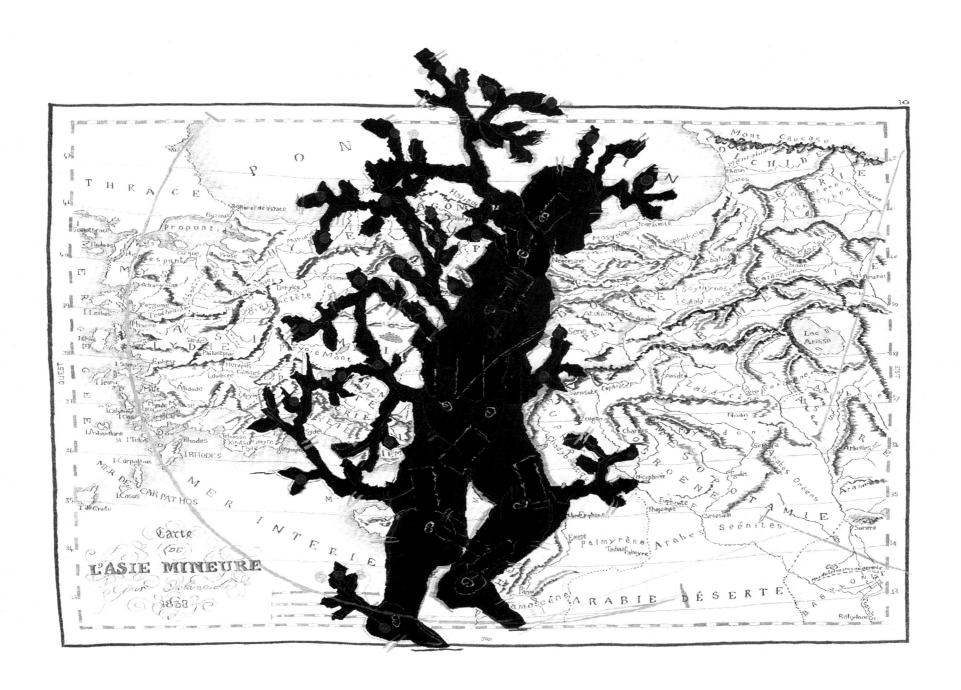

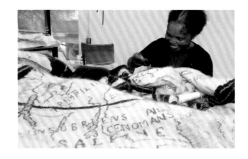

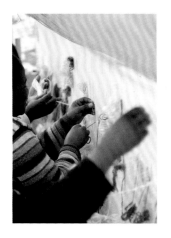

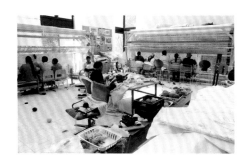

PLATE 26
Porter Series: Espagne ancienne (Porter with Dividers), 2005

Tapestry weave with embroidery. Warp: polyester. Weft and embroidery: mohair, acrylic, and polyester
98¾ x 132½ inches (250.8 x 336.6 cm)
Woven by the Stephens Tapestry Studio
1st artist's proof (of 2)
Courtesy of Lia Rumma Gallery, Milan

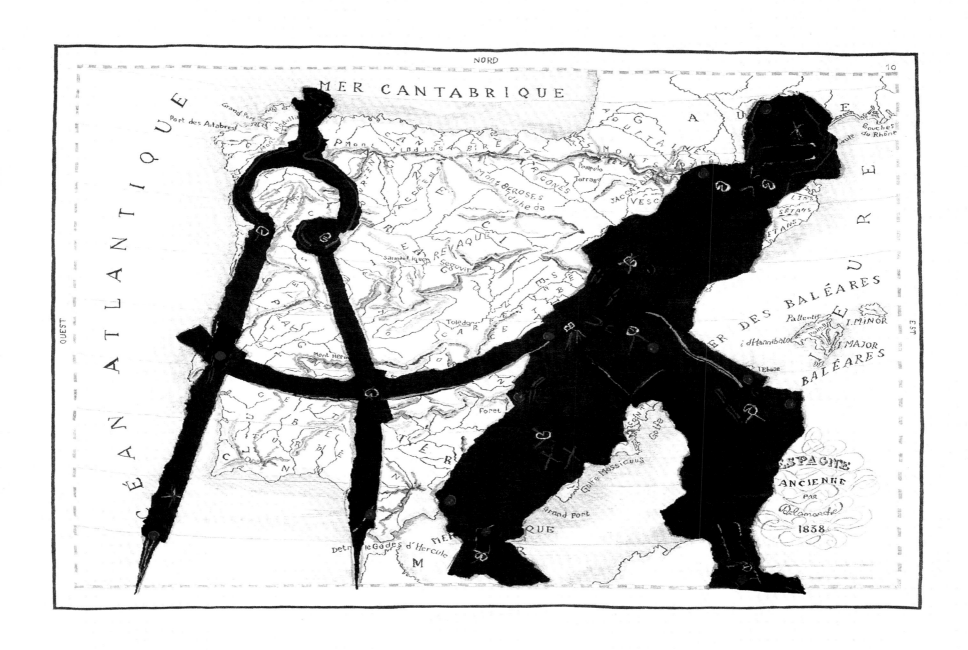

PLATE 27

Porter Series: Géographie des Hebreux ou Tableau de la dispersion des Enfants de Noë, 2005

Tapestry weave with embroidery. Warp: polyester. Weft and embroidery: mohair, acrylic, and polyester
100½ x 137⅞ inches (255.3 x 350.2 cm)
Woven by the Stephens Tapestry Studio
Edition: 3/3
Collection of Anne and William Palmer, New York

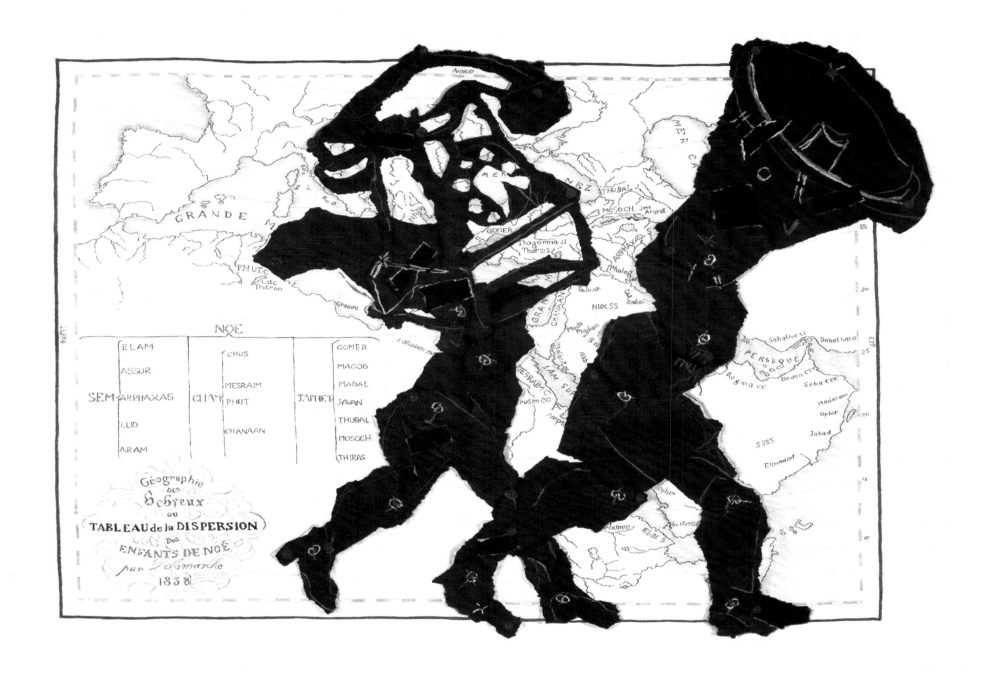

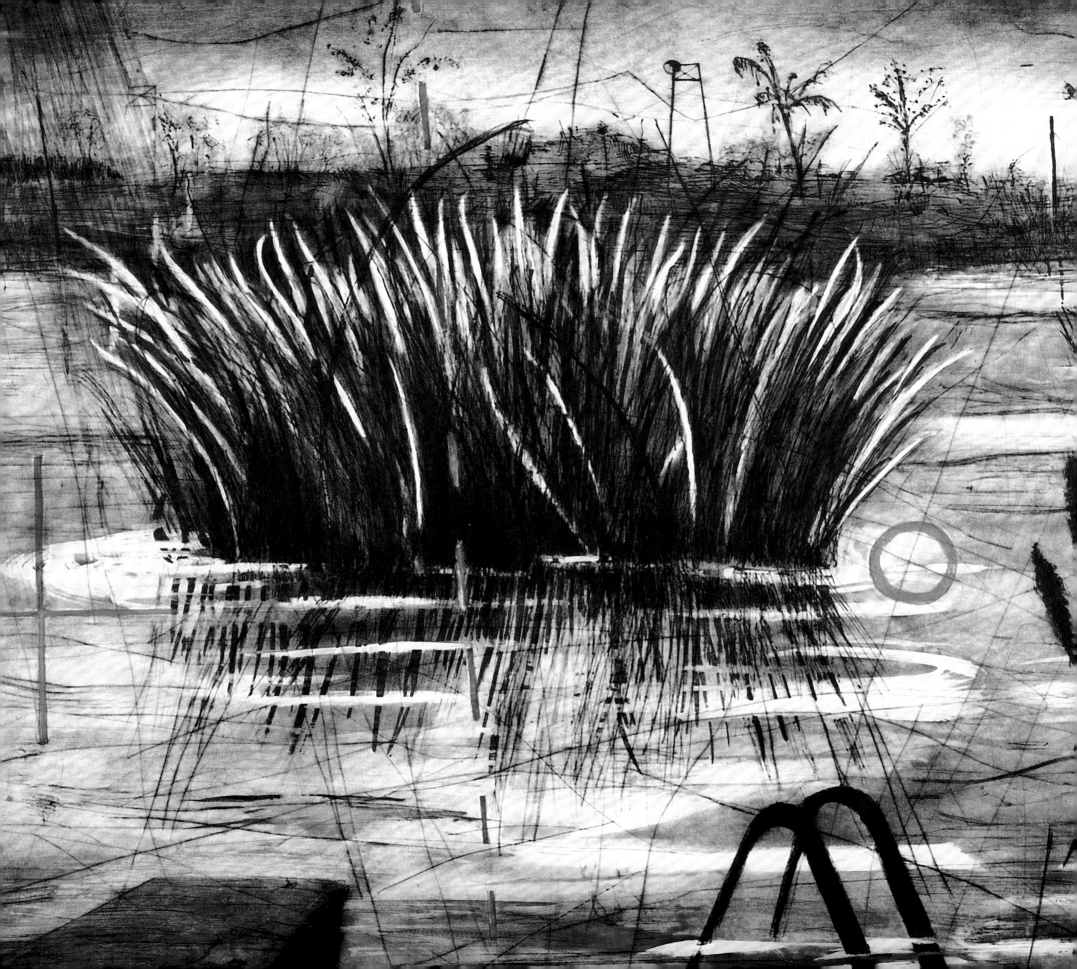

(Un)Civil Engineering: William Kentridge's Allegorical Landscapes

OKWUI ENWEZOR

In the series of tapestries, drawings, and sculptures that form the crux of this exhibition, William Kentridge continues to incorporate into his artistic repertoire new mediums for recording the same concepts that have been the signature, if not the set pieces, of his artistic thinking. In the tapestries, figures from his previous works recur like unvanquishable hobbyhorses: hybridized bodies, sometimes paired with prosthetic attachments (an old-fashioned cash register or megaphone for a head, or legs composed of electric pylons [plates 17, 18, 27]); objects such as showers (plate 19), bicycles (plate 24), telephones (plate 27), or chairs (plate 22); and scenes, mostly imaginary landscapes projected against the backdrop of maps. Kentridge deploys these deeply embedded forms and images as more than mere props to designate a style. Rather, they serve as metaphors for addressing a range of psychic and emotional topics related to his work over the last three decades in the visual arts, theater, and opera. Almost akin to characters, they appear repeatedly in his work as instruments to tease out the unruly relationships between the past and present, history and consciousness, place and memory.

Kentridge's work derives not just from his own powerful analytical observations, but also from profound and thorough expressionistic explorations of the apartheid grotesque of his native South Africa through earlier European examples such as the documentary style of Francisco de Goya, the figurative work of Max Beckmann, and the graphic quality of Käthe Kollwitz—though we must also include as important influences the work of South African artists such as Dumile Feni and Ezrom Legae (figs. 18–21).[1] As has been noted frequently,[2] Kentridge's drawing style—which forms the basis for all of his works, regardless of medium—is influenced by German Expressionism and the intentionally crude, "primitive" mode through which its artists designated and represented the human figure. These sources convey something essential to understanding Kentridge's sympathies as an artist as well as the ethical nature of his art—namely, the way in which the philosophical outlook of early modernists underscores his interests in the contradictions of Enlightenment reason and the violence that accompanied its promulgation in colonial practices. He uses these sources to lay bare for his cosmopolitan viewers the face of apartheid, but also to implicate them in seeing this racist ideology's origins in European political ideologies and romanticism.

The intersection between Europe and Africa—the attempt by one to dominate the other, and the struggle by the other to resist and overcome unequal power relations—remains the central articulating point on which Kentridge's figures, forms, and objects converge on the landscapes that dominate his work. It is not just the landscape engineered by colonialism, and further deformed later by apartheid, that serves as a key emblem for the artist, but also the perspectival lens borrowed from Europe that gave the South African landscape its picturesqueness—or, as some would say, its jaundiced coloration as a savage landscape in need of taming. On the latter point, the South African writer J. M. Coetzee asks a particularly poignant question: "Is there an African species of beauty to which the eye nurtured on the European countryside, trained on European pictorial art, is blind?"[3]

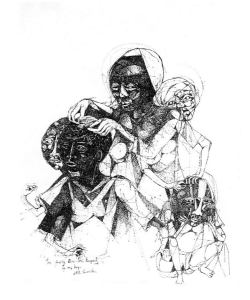

Clockwise from top left:

Fig. 18. Ezrom Legae (South African, 1938–1999), *Chicken Series*, 1978. Pencil, oil wash on paper; 18¼ x 10 inches (46.5 x 25.5 cm). Courtesy of Warren Siebrits Gallery, Johannesburg

Fig. 19. Max Beckmann (German, 1884–1950), *The Martyrdom*, 1919. From *Hell*, a portfolio of eleven lithographs; sheet 24³⁄₁₆ x 34³⁄₁₆ inches (61.4 x 87.2 cm). The Museum of Modern Art, New York. Larry Aldrich Fund (306.1954)

Fig. 20. Dumile Feni (South African, 1939–1991), *The People When We Respect to My Boy*, undated. Pen and ink on paper; 13¹³⁄₁₆ x 10¼ inches (35 x 26 cm). Courtesy of Warren Siebrits Gallery, Johannesburg

Fig. 21. Käthe Kollwitz (German, 1867–1945), *The Volunteers*, 1922. From *Seven Woodcuts about War*; 13¹³⁄₁₆ x 19⁵⁄₁₆ inches (35 x 49 cm). Edition "A" (56/100). Location unknown

If the European landscape served as a model for Kentridge on how to think and unthink the South African landscape, consider a conventional contemporary European landscape observed from the vantage point of the early twenty-first century. Such a landscape, with its carefully manicured fields full of lush greenery, may point to the idea of the cornucopia of the farmland, or to the abundance of nature that farming brings to the tables of ordinary people while filling the coffers of multinational agribusiness corporations. At the same time, this landscape may also mask the inscriptions that traumatic incidents have made upon it. Rows of trees jutting from a clearing in a replanted forest, for example, may intimate more sinister events that took place there decades earlier. In this way, landscape has the capacity to hide its own evidence or serve as a mute witness to the unseen legacy of its traversal, whether by a plow or a machine-gun squad facing a column of men in the darkness of the forest. Scenarios such as this have served Kentridge as a critical perspectival tool for how to read a landscape not just as a bucolic ideal but also as an archive of political analysis. In an interview I conducted with the artist in 2005, he made explicit how such analysis informs his artistic thinking:

> In *Felix in Exile*, which was made in 1994 at the time of the first election, there was a lot of political violence in South Africa. One of the questions in the film is the way in which the landscape absorbs its history: where there's been a battle, where there's been a disaster, where there's been a massacre. And the landscape itself, after a certain length of time, kind of hides those traces. It seems inconceivable that one should see a beautiful forest when in fact, it is where 50,000 Polish officers were shot by the Russians — the Katyn Forest. But when you actually look at the pictures of the forest, it's very difficult to find that place in the forest, all you can see are certain places where trees, instead of being random, have been replanted in straight lines. And that's a clue of what happened.
>
> In the film, I was interested in thinking about the way in which the landscape forgets its history, as a metaphor for the way we forget our history.[4]

For Kentridge, this clearing in a Polish forest not only alluded subconsciously to a mass killing, but also served to remind the viewer of the entire disturbed historical memory of twentieth-century Europe. Being himself of European ancestry, and very much enamored of the refined culture of Mittel Europa of the late nineteenth and early twentieth century, Kentridge was obviously remarking on more than mere perception. Rather, he was laying out the groundwork for denying us any romantic idea of the innocence of picturesque landscape as received in the representations of the classical age.

Coetzee makes the point that the idealized, not to say the ideologized, view of landscape emerges under the sovereign regard of the pictorialist lens: "Landscape is picturesque when it composes itself, or is composed by

the viewer, in receding planes according to the Claudian scheme: a dark *coulisse* on one side shadowing the foreground; a middle plane with a large central feature such as a clump of trees; a plane of luminous distance; perhaps an intermediate plane too between middle and far distance."[5] In Kentridge's art, no such landscape composes itself as one would a picture, and for that very reason he insists on the nature of his representation of the South African landscape as anti-picturesque.

Twenty years ago Kentridge explained why his work resists the idyllic pictorial convention that describes the picturesque:

> One thing that has always struck me about the depiction of South African landscape . . . is that it has never corresponded to the landscape as I have seen it. What is usually depicted is the landscape observed, in a motorcar, while driving through it, rather than into it; and it is usually described as alien, antagonistic, "other."
>
> . . . It's a characteristic of these rather desolate, barren, and unstructured pieces of veld that you have a perfect white line drawn through it by pipeline, which runs totally straight all the way across it. Or you might, in an undulating landscape, have a sudden level horizon, where there was a mine dump. This has now become part of the landscape.[6]

The South African veld that Kentridge reminds us of is a constructed image, and one in which we must also foresee and incorporate elements of its changing nature. It is no more a pictorial fact filled with the fantasies of the observer than it is a dystopic space apprehended through the rapacity of the modern industrial processes that help determine its image as an object of representable reality. For example, the forces of civil engineering and mining that mark its surfaces and change its pictorial composition are what allow Kentridge to distinguish between the veld as a space seen from the window of a moving car and the somatic experience of the same space as one drives into it, which conveys the sensation of relating to it as one would to an object rather than an image. In a similar vein, Kentridge's representation of the clearing in Katyn Forest in Mittel Europa—where neatly planted rows of trees allow him to make viewers aware of the clear historical purpose of drawing a space where 50,000 Polish soldiers were executed—evokes the same non-innocent approach to thinking about the landscape. Clearly, the boundless veld of the South African landscape in which he grew up, and with which he is much more familiar, is similarly lacking in innocence.

The relationship between conventions and modes of perception is integral to any meaningful explication of Kentridge's deep philosophical meditations on his ambivalent relationship to nature and landscape. The specific occasion on which I recalled Kentridge's comment about the Polish landscape was while I was traveling by train between Lausanne and Geneva. The unremarkable yet appealing monotony of the Swiss countryside with its lakes,

mountains, and fields seemed to underscore the idea of the innocence of landscape. If this very European land-
scape has any special attribute, it is the generic quality of the carefully planned, repetitive relationship between
sustainable agriculture and the modern infrastructure that supports it. The train's picture window offered a perfect
frame from which to observe the almost mundane way the contemporary European landscape is made. This is
not the landscape of sixteenth- and seventeenth-century Dutch paintings. Nor is it the allegorical views of ruins

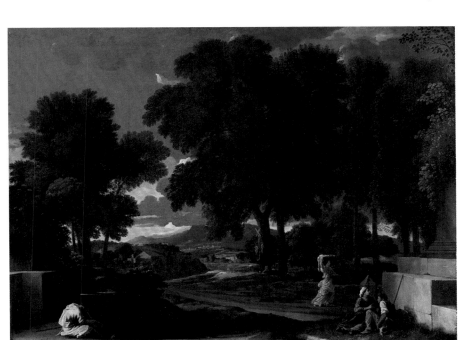

Fig. 22. Nicolas Poussin (French, 1594–1665), *Landscape with a
Man Washing His Feet at a Fountain*, c. 1648. Oil on canvas, 29⅛ x
39½ inches (74 x 100.3 cm). The National Gallery, London.
Presented by Sir George Beaumont, 1826

of the classical age seen in Italian paintings of the seventeenth century. Nor is it Nicolas
Poussin's mystical landscapes, especially of the shepherds in the Vale of Tempe (fig. 22).
Nor is it the English landscapes of cultivated fields that reveal the class relations between
the gentry and the peasantry. In these other cases, nature was not so much subordinate to
man's lofty ideals of progress as it was designed as a series of relationships that convey aes-
thetic meaning, philosophical observation, and contemplative enjoyment. The Dutch, for
example, painted the landscape as part of the scenes of everyday life: of labor and harvest;
of humans and their environment. In the allegories of Italian landscape painting, and in
Poussin's celebrated images, the historical and the metaphysical are blurred in celebration
of an imagined heritage.

The European landscape today bears little relationship to those described above.
Seen from a speeding train, its repetitive motifs unfold as a dialectic between agrarian
discipline and postindustrial development. The gentle rhythms of ridges planted with
grape vines slope downward to the edge of the flatland, where a road bisects the view.
Across the road, a field climbs a hill in alternating bands of green and ocher and gives way, around its serrated
edges, to a clump of red-tiled roofs atop the nondescript boxes of Swiss domestic architecture. From here, as the
train hurtles toward its destination, a collection of objects—electric pylons, gigantic communication towers, tall
metal windmills, train tracks, service roads, and the highways clogged with trucks, cars, RVs, tractors, and the
like—intervene to remind us of how modernity has intruded into our apprehension and experience of nature.
Grown like trees in a forest, these objects constitute part of the progress that is the tether of modern society.
Modernity has made obvious the fact that the ideal landscape belongs to the past.

The South African landscape that forms the principal subject of Kentridge's early films resembles in many
ways the Swiss landscape just described. But while their settings evoke similar juxtapositions between industrial
processes (pipelines, pylons, telecommunication towers, mine dumps) and traditional agrarian life (well-tended
plantings, fields with grazing livestock), the terms of their making and reception are poles apart. The European
and South African landscapes are differentiated not simply by the natural settings and traditions associated with
each, but also by the fundamental view of the South African landscape as defined first by ideology.

South African photographer David Goldblatt's seminal but surprisingly unremarked 1993 photograph *Remnant of a hedge planted in 1660 to keep the indigenous Khoi out of the first European settlement in South Africa* (fig. 23) confronts us immediately with a radically troubled relationship to space and environment, habitus and habitat. Goldblatt's photograph makes us aware of the ways in which human beings set limits around certain territorial claims that then generate other meanings for the landscape. It reminds us of the radical difference between the pictorialist purpose served by landscape in the work of Dutch painters from the period when the hedge was first planted by Jan van Reebeck's band of early Dutch settlers, and the clear purpose of landscape in the colonial and apartheid imaginary as first and foremost an experience of boundary, a delimitation and diminution of access to space, a territorial limit not so much cultivated as purposefully constructed. Through this experience we come to understand the brutal ideological means by which the South African space was constituted as a series of segmentations, quarantines, denials, thwartings of access, and refusals of cohabitation. From its earliest inception the colonial enterprise placed all transactions concerning space and landscape under the permanent auspices of negotiation and contestation, to the degree that the views of land and nature were radically constituted by questions of power.

Borrowing from Goldblatt's subtle yet coruscating examination of South African

Fig. 23. David Goldblatt (South African, born 1930), *Remnant of a hedge planted in 1660 to keep the indigenous Khoi out of the first European settlement in South Africa, Kirstenbosch, Cape Town, Cape, 16 May 1993*. Gelatin silver print. Courtesy of the artist and the Goodman Gallery, Johannesburg

spatial forms, Kentridge has in turn taken the relationship between human beings and nature as foremost a work of civil engineering. In the recurring images of spatial production that Kentridge includes in almost every series of drawings, films, theater sets, and, latterly, in the tapestries, the interventions are made not by natural forces, but by human forces under the control of modern capitalism, which are laid bare for all to see. It is a landscape of modernity, progress, and industry. At the same time, we are forced to examine this postindustrial site as a way of thinking about the post-apartheid landscape and what could become of it.

In drawings for the film *Mine* (1991), we behold black miners blasting away at the hollow core of a gold mine, the center of which is bifurcated by a railway line. In *Woyzeck on the Highveld*, tree stumps jostle with white cuboid structures and wooden stakes driven into the soft soil, while an architectural ruin sits bracketed by two mine slurries. In *Felix in Exile*, the title character wades naked through a pool of blue water amid a desolate, portentous landscape peopled with shrouded bodies and wooden stumps (fig. 24). In the drawings that accompanied the production of the play *Faustus in Africa!*, a giant tree in a bleak landscape becomes the load-bearing structure for three lynched black figures. Other drawings from this suite reveal the incongruousness of such scenes of brutality with a laconic cascade from a waterfall. In *Weighing . . . and Wanting* (1997) rocks transmogrify into X-ray scans of the head of Soho Eckstein, which in turn is transformed into a looming boulder dominating a landscape

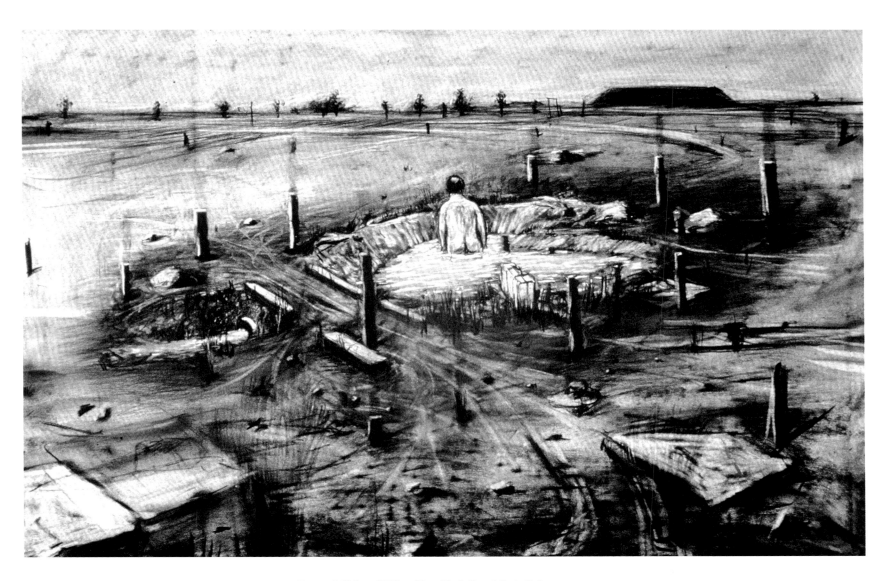

Fig. 24. Still from William Kentridge's film *Felix in Exile*, 1994.
Courtesy of the artist

of infinite sky and space. In these varied scenes, the South African landscape is represented explicitly as anything other than part of the natural world. It is a space of anomie. In the films, as we watch the giant electric pylons crash in a dizzying fall of dramatic erasures and caesuras, we read the surrounding bleakness as an allegory of the landscape to come.

Kentridge has returned obsessively to the South African landscape as a means of thinking through the history and incidents of colonialism. The unique properties of the South African veld have become for the artist, like Goldblatt before him, a way to address the consciousness of landscape as more than a formal tool of spatial investigation. Kentridge's South African landscape drawings express graphically the relationship between human beings and their environment, as well as their will to impose power and vision upon its topography. The subtle violence that accompanies each such imposition—the unearthing of every rock, the relocation of a cut boulder, the laying of roads, the building of pylons, the excavation of a mine, the creation of the soft-edged mounds from mine dumps that grow over time to be hills, the invention of the bleak townships and Bantustans—begins to reveal the imaginary within which the landscape acquires a series of somatic attributes as part of a vast process of social engineering. These attributes have to do with the remaking of the environment, the consciousness with which the topography is altered as the work of civil and mechanical engineering. In Kentridge's work, engineering is more than a technical term for conceptualizing the South African landscape in relation to the country's colonial and apartheid past. Engineering is both a literal method of its making, especially in the types of landscapes described in his obsessive and often elusive drawings, as well as the manner in which the ideologies of settler colonialism understood and developed the South African space and cultural sphere.

For all the opprobrium on the one hand and ecstatic reception on the other that have accompanied Kentridge's rise as one of contemporary art's most distinguished thinkers and artists, his work is far from the kind of reductive crudity often attributed to it. The questions raised by his work originate in South Africa and its history, especially its modern history as a zone of isolation and of naked life,[7] a vast work camp in which black subjects lose all claims to sovereign subjectivity. What is the nature of domination in relation to the instincts of resistance that counteract it? What sort of environment produces apartheid, which in turn transforms the landscape of hospitality and neighborliness into a dangerous zone of violence, violation, pillage, subjugation, and institutional mendacity? Is the apartheid space a corruption of the aesthetic romanticism of landscape as an objectively depictable scene of nature in all its abundance of uncomplicated pictorial enjoyment, or does following the straight lines of the replanted forest lead the viewer to the vanishing point of desolation? And finally, while landscape can hide its memories, is it not the work of the artist to undermine such easy amnesia?

1. Kentridge has consistently cited as an important influence Dumile Feni's forceful and emotionally dense large-scale charcoal drawings, which are drawn in a figurative and realist mode, often dealing with issues of social oppression and oppositions to power. See Carolyn Christov-Bakargiev, "Introduction," in Christov-Bakargiev, ed., *William Kentridge*, exh. cat. (Brussels: Société des Expositions du Palais des Beaux-Arts, 1998), p. 27. Ezrom Legae's pen-and-ink drawings, though drawn in the same figurative manner, are much more subtle in their allusive allegorical approach to politics. For example, Legae would use a white sheet of paper to designate a field, in a graphic image of a slaughtered chicken that could be read as the machinery of violence unleashed by the apartheid state against its black opponents.

2. See Michael Godby, "William Kentridge: Four Animated Films," in Christov-Bakargiev, ed., *William Kentridge*, pp. 165–66.

3. J. M. Coetzee, *White Writing: On the Culture of Letters in South Africa* (Sandton, S. Africa: Radix, 1988), p. 38.

4. "On the Nature of Vision and Visuality in the Landscape of South Africa: William Kentridge Speaks with Okwui Enwezor," *FYI*, no. 1 (May 2005), pp. 19–20.

5. Coetzee, *White Writing*, p. 39.

6. Rose Korber, "Revealing the Truth of Veld that Lies," quoted in Christov-Bakargiev, ed., *William Kentridge*, p. 161. J. H. Pierneef has variously been described as one of South Africa's most important artists and as a proto-apartheid painter. The latter point relates to the way in which his paintings of the South African landscape are almost always devoid of human settlement. These representations of space in a pristine, primitive state are a trope common to settler colonialism's perspectival depiction of aboriginal landscape as essentially *terra nullis*. The degree to which Pierneef's painting is consciously ideological in this manner could be disputed, especially since recent revisionist interest in collecting his work has decidedly cast his paintings of the empty South African landscape as a kind of spiritual celebration of the majesty of the space.

7. This term was coined by the Italian philosopher Giorgio Agamben to define the way the modern apparatus of authoritarian power and totalitarian regimes transform the very vehicle on which modern biopolitics is founded. "Naked life" as such becomes the zero degree of one's possession of any identifiable instrumentality that can be likened to sovereignty or even free will. In this liminal zone, naked life is thus the loss of that capacity. See Giorgio Agamben, *Homo Sacer: Sovereign Power and Bare Life*, trans. Daniel Heller-Roazen (Stanford, Calif.: Stanford University Press, 1998).

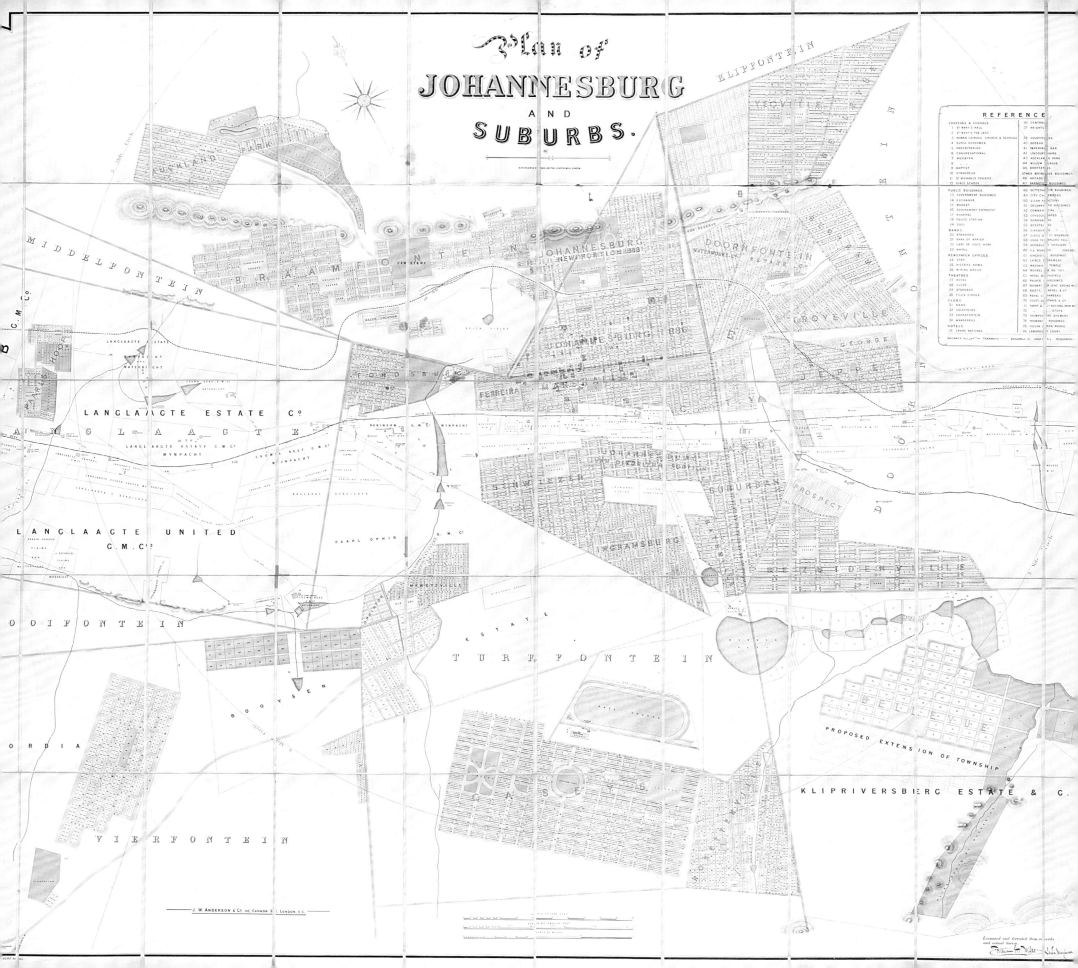

A Farm in Eloff Street

IVAN VLADISLAVIĆ

"There used to be a farm here," my friend said, pointing across the intersection. "I picked peaches there with my brother when I was nine or ten. They gave you a pail and you went into the orchard and filled it up yourself."

We were driving in the northern suburbs of Johannesburg. The corner she meant was occupied by a car dealership, three tiers of silver pillars and plate glass on which cars were arranged like ornaments in a showcase. Its extravagant insubstantiality helped me to imagine the shaded *stoep* of a vanished farmhouse, trees with lime-washed trunks and fruit-laden branches, the farmer's wife with a bucket in the crook of her arm. A bucketful of that incomparably sweet and juicy fruit, I thought, would surely cost two and six. When you speak to people who grew up in the thirties and forties, like my friend, that nostalgic figure seems to be the measure of everything that was once dirt cheap and is now costly. A gallon of petrol? Two and six. Your first high heels? Two and six.

Charmed by the detail of her recollection, I was slow to appreciate that it was not all that remarkable. You could point to practically any corner of this city and say, "There used to be a farm here."

Gold was discovered on the Witwatersrand in 1886.[2] The formal city—the part of it we now think of as the central business district (CBD), the old city center—was laid out in October of that year on a small triangle of *uitvalgrond*, or wasteland, between the farms of Braamfontein, Doornfontein, and Turffontein. This waterless triangle called Randjeslaagte was chosen precisely because it was the only scrap no farmer had claimed. All around lay a ragged patchwork of farms, almost invariably named for a water source in the form of a *fontein* or *vlei*, from Waterval, Klipfontein, and Cyferfontein in the north to Diepkloof, Misgund, and Olifantsvlei in the south.[3]

Traces of these origins can still be found in the city today, hinted at in the name of a suburb or the angle of a street. The suburbs of Bezuidenhout Valley and Judith's Paarl, not far from where I live, were named after Frederick Bezuidenhout and his wife Judith, who farmed a portion of Doornfontein. The original farmhouse and small family graveyard are in Bezuidenhout Park. The phrase "the original farmhouse" has long been exploited by estate agents to talk up a sale in one of the older suburbs. We have a running joke in my neighborhood that every last one of us lives in "the original farmhouse."

The city, as it grows, has always been bumping up against working farmland and devouring it. In the early sixties, Nelson Mandela, Walter Sisulu, Wilton Mkwayi, and other leaders of the recently banned African National Congress (ANC) hid out at Lilliesleaf Farm in the countryside north of Johannesburg. Today the original farmhouse, now operating as a small hotel and conference center, is in the middle of a densely built-up suburb,

surrounded by strip malls and office parks. Sandton City and Nelson Mandela Square, the immense malls and office towers that mark the city's new commercial center in Sandton, are just a few kilometers away.

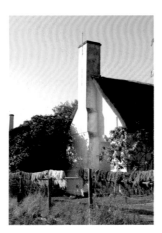

When I was a child, a catchphrase was used to discount an improbable claim or boast. "If you can run a four-minute mile," my father might have said, "I'll buy you a farm in Eloff Street." Eloff Street was then the most expensive, stylish real estate in the CBD.

The expression says something about the explosive urban growth that occurred on the Witwatersrand. Within a few decades of its founding, the builders of Johannesburg had managed to reverse the reality of farm and city. In the 1880s, someone gazing over the farmland of Doornfontein and Braamfontein could scarcely have imagined that a *city* would rise there. Half a century later, the concrete fact of the city was so incontrovertible that the idea of a *farm* in this urban space seemed inconceivable.

Another half-century later, the expression has faded from use. Eloff Street is no longer the fashionable heart of the city: much of the money has migrated north, a shift of economic power sealed by the relocation of the stock exchange from the CBD to Maude Street in Sandton in 2000. In any event, a farm is no longer the most obvious example of landed property. What would be an equivalent catchphrase for contemporary Johannesburg? I'll buy you a golf estate in Maude Street?

In his writing on the farm novel, J. M. Coetzee singles out Olive Schreiner's *The Story of an African Farm* (1883), which towers over the beginnings of South African literature in English, and Nadine Gordimer's *The Conservationist* (1976) as the high points in a local antipastoral tradition.[4] To this pair one might add Coetzee's own *In the Heart of the Country* (1978) and *Disgrace* (1999).

South Africans took *Disgrace* to heart. A largely urban readership, more accustomed to fighting for parking space than land rights, was unusually provoked by a book whose moral crux lay in the price to be paid for having a farm in Africa. In a society emerging from an oppressive history, *Disgrace* asked complex questions about sacrifice and responsibility, and it touched the nerve that joins ownership and belonging.

The farm is a potent metaphor in the South African imagination. Many city people are still linked to farms through family or a home in the rural areas. The farm also has qualities that allow it to stand for the country and its fate. Farmland tends to stay in the same family and so represents specific, continuous ownership, as opposed to the more diffuse, provisional ownership associated with the city. The loss of a farm, through economic hardship or dispossession, is seen as disrupting a lineage. The bond that people develop with a farm is also perceived as a spiritual one, reaching deeper than the merely technical ownership one may be supposed to exercise over a suburban plot. On the farm, people put down roots and find a place in natural cycles, and their labor

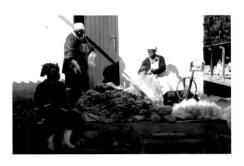

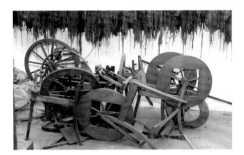

naturalizes the bond between a family, or a nation, and the land. Occupied by a community of owners and workers, and operating as a more or less distinct economy and ecology, a farm has an obvious synecdochic relationship to the country as a whole and may be taken as a model for broader social, economic, and political processes.

This metaphor has never been explored more fully than in Marlene van Niekerk's *Agaat* (2004).[5] One of the central novels of the South African transition, it refracts an epic history of ownership and belonging through the domestic melodrama of the relationship between two women. The setting is the farm Grootmoedersdrift. Agaat Lourier, the neglected infant daughter of a coloured[6] housemaid, is taken in—or taken away—by Milla Redelinghuys, the white farm owner, who raises the child as her own. But when Milla conceives a child herself, the seven-year-old Agaat is banished to the servants' quarters and remade as a house servant. The novel plays out in a much later period, the years just after the first democratic election of 1994, when the women's roles have been reversed by age and illness. Milla, reduced to immobility by motor neuron disease, is dying. After a lifetime of command, running her family and farm, she is more helpless than a child, managing to communicate only by the flickering of her eyes. Agaat, after a parallel lifetime of servitude, is in charge of all Milla's needs, the "commander of [her] possibilities" (p. 55). She keeps Milla alive, feeds her, washes her, medicates her, intuits her wishes, and also frustrates them. She is both loving and vengeful.

In summarizing the book, I have fallen back on the opposition of mistress and servant. But it is precisely this opposition that the book dissolves. Agaat and Milla fit together like two halves of a mold. They do not represent strength and weakness, dominance and submission; rather, the substance of these conditions lies between them. They have shaped one another with their hands and eyes. This is Milla thinking, but it could just as well be Agaat: "Tell the man our imagination is a shared one, tell him we thought each other up" (pp. 211–12). What they express is often a hybrid of their contrary intentions and combative wills. Through such an understanding of power and how intricately it binds, Van Niekerk unlocks some of the paradoxes of the broader society that is the book's true subject.

Maps figure prominently in *Agaat* as signs of ownership. Like graphic title deeds, they are produced when property changes hands, defining the terms of the exchange and reducing an extensive territory to a manageable scale, a tabletop empire. The novel also treats maps more evocatively as registers of attachment to place. Milla's illness has abstracted her from the world and she can no longer write or speak, but she is soaked through with experience, as sodden as a piece of low-lying earth. Frequently, thinking about parts of the farm she can no longer visit releases a flood of vivid images in her mind. "Memories in me and I awash between heaven and earth. What is fixed and where?" (p. 81). In this drifting, fluid state, she longs to see the maps of her farm, whose "fixed points, veritable places" (p. 40) promise to bring order and stability. She imagines "hooking" her eye to the little cartographic symbol of a bridge, grafting her imagination to the schematic plan. At one point, she pictures herself as a

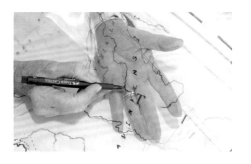

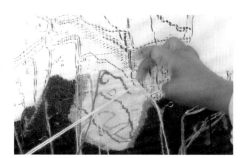

container for the maps: she imagines her head being removed and the roll of maps slid into her wasted body like a spine (p. 105). In *Agaat*, maps are like skeletons or armatures on which the flesh of memory depends.[7]

Milla's frustrated longing to see the maps—a hunger not for land but for its representation, for the power of representation itself—is a crucial arc of conflict in the novel. Milla signals in vain for Agaat to fetch the maps and show them to her; Agaat obstinately refuses to get the message. This tussle of wills pits two versions of the world against one another. The maps give form to Milla's version: they are markers of her identity, they speak her language and anchor her memories. She names the familiar places on the maps—"kraals, corners, ridges, heads, holes, heights, bowers, plains" (p. 403)—as if they were a spell. To the extent that the farm has drained into her body through the senses, and the map activates this internalized world, the land might be seen as her inalienable property.

For a large part of the novel, Agaat suppresses Milla's version of the world by refusing to show her the maps. When she does finally bring them out, it is to humiliate Milla. The scene unfolds as low comedy. Agaat has plied Milla with a laxative, and so the revelation of the maps is accompanied by the voiding of Milla's bowels. The lofty theme of attachment to the land, which has been conveyed movingly by her longing for the absent maps, is undone by some truly lavatorial humor.

Having unfurled the maps, Agaat goes on to impose her own subjective order on them. Seizing the power of naming—a prerogative of the powerful—and turning it back on Milla, she reels off the names of farms, stations, towns, battle sites, railway junctions, rivers, dams, and mountains. The world is remade as she releases a flood of her own associations, tying each place to a memory of a hurt endured or an indignity suffered. From the same paper dominion, but following "her own routes" (p. 406), she reads off an alternative history of subjugation.

In times of social transformation, the revision of history and the reshaping of the physical world go together. Territory is reclaimed through being renamed. The remapping of a future South Africa was agreed to in 1993 during the multiparty negotiations toward a democracy. One of the first major planning initiatives of the post-apartheid state was to remodel the provincial system, replacing the four provinces of the colonial era with nine new ones, and erasing apartheid entities such as the "homelands." The renaming of towns and streets still continues.

The civic virtue of long-established place-names, as Michel de Certeau argues, is that custom has severed their link with actual persons or events and rendered them comfortably neutral. The names of streets, squares, and suburbs "slowly lose, like worn coins, the value engraved on them"[8] and become open to a multiplicity of subjective meanings. It is a mark of how contested South African spaces are that the "rich indetermination"[9] De Certeau mentions has scarcely had time to develop. The values engraved on place-names are still felt, and plans to rename colonial cities like Pretoria have proved controversial.[10] While most black South Africans regard renaming as the

justifiable restoration of a suppressed indigenous history, many whites see it as a negation of their place in the contemporary society. People may feel the loss of symbols more acutely than the loss of direct political power or economic status.[11]

The renaming of places transmutes associations in complicated ways. Goch Street in Newtown, to take one example, was named after a speculator who founded a mining empire on the Rand. By 2004, when the street was renamed for the great investigative journalist Henry Nxumalo, few Johannesburgers would have been able to identify George Goch. But for some, the mention of Goch Street would have summoned another name: Solomon Mahlangu. It was here, in June 1977, that the ANC guerrilla was captured in a shootout with police. Two years later, he was hanged by the apartheid government. When "Goch Street" was painted out on the curbstones in Newtown, these echoes of Mahlangu's story faded away too.

We take the residues of places with us, even as we leave them behind in the concrete streets. William Kentridge expresses this double bind in his work. His porters and refugees, silhouetted against maps like actors against backdrops, carry the precariously balanced necessities of an accommodated life—a bed, some chairs. Yet they seem burdened less by this baggage than by the maps of old cities and vanished countries before which they pass. The weight of this history is in their bodies and they cannot put it down.

In *Agaat*, as many commentators have pointed out, Van Niekerk reinvents the *plaasroman*, or farm novel, a genre that is central to the Afrikaans literary tradition. Like the work of her forerunners in the twenties and thirties, Van Niekerk's novel processes a moment of historical crisis. Whereas *plaasroman* writers such as C. M. van den Heever, Jochem van Bruggen, and Johannes van Melle dealt with the end of the peasant order, as Afrikaners lost their land and drifted into the cities, Van Niekerk deals with the end of the apartheid order and the Afrikaner's loss of political power. In the process, she revises or parodies aspects of the *plaasroman* that defined the Afrikaner's relationship to the land.

The connection between family and farm was central to the earlier *plaasroman* and remains central here. But Van Niekerk complicates the notion of "family" through the figure of Agaat, who is first brought into the farmhouse as a surrogate child and then expediently relegated again to the servants' quarters. The question of Agaat's place in the home addresses on a small scale the broader debate about the qualifications required for inclusion in the *volk*, the national family of Afrikaners.

In the traditional *plaasroman*, to take another of the themes suggested by Coetzee, labor, and especially black labor, must be effaced, as the presence of poor black workers on the farm cannot be accommodated without disrupting the rural idyll the book constructs. *Agaat* reverses this repression with a vengeance. Black farmworkers are present constantly and the demands of farm labor—slaughtering, ploughing, tending to sick animals—are

described in visceral detail. We are never allowed to forget that a farm is a place of labor—and not the heroic kind that is its own reward, but backbreaking, poorly paid toil for definite ends. In this world, the purpose of labor is more often to discipline and punish than to ennoble.

In Van Niekerk's revision of the scheme of things, the male farmer, when he is not actually absent, is frequently reckless or inept, and women take charge in the fields and kraals. She also shifts the focus indoors, to the work done by women in the laundries, kitchens, and pantries. Here women's work, far from contributing to "the refinement and beautification of the domestic atmosphere,"[12] may be a source of subversive power.

Agaat is taught needlework as a practical discipline, a way of keeping her hands busy in the "outside room" and supplying herself with uniforms. But she uses this skill defiantly to embroider stories of her own and to assert a claim on the farm and its activities. Her creations in cloth and thread, which are often narratives of farm life in their own right, may be seen as idiosyncratic, personal title deeds to Grootmoedersdrift, a challenge to Milla's authoritative maps.

Agaat's final household chore before assuming ownership of the farm is to usher Milla from life into death, a long and painful task often likened in the novel to farming. And the culminating handiwork of her life— her masterpiece, if you like—is the ornately embroidered shroud in which Milla is buried. The mistress is sewn into her own story. More precisely, the mistress is sewn into a version of her story told by her servant.

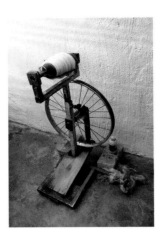

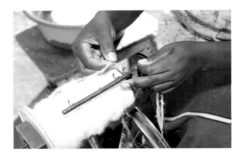

Milla and Agaat are unique creatures. But the novel asks to be read allegorically, so let me shear them of their idiosyncrasies and see what they might stand for.

Van Niekerk's novel ends with the death of Milla, representing the old order, and the effective passage of ownership of the land to Agaat, representing the new. Milla's son, who by rights should have inherited the farm, has emigrated to Canada, forsaking property, climate, and language. Thus an Afrikaner family lineage is broken, while a female lineage, expressed in the name of the farm, is extended.

However, the allegory of transformation has limits. This is not the story of Agaat's redemption; the signs are that she will continue Milla's tyrannical regime and things will not improve for the farm's workers. *Agaat* is a book about change, but of a modest, uncomfortably intimate kind, composed of painful accommodations and humorous revenges. The book's structure is symmetrical. Consider it as a large mirror image, and it shows that the strong and the weak have traded places. But examine the facets carefully and the mirror images multiply, until "before" and "after" run together. Where does the power lie? Is Agaat serving Milla or vice versa? Who dictates the terms of their exchange? Who is punishing whom? Whose debts are greater?

It would be more precise then to say that the novel's structure is one of apparent symmetry. In this it resembles South Africa's recent history, in which change presents us with two baffling faces. Thirteen years after

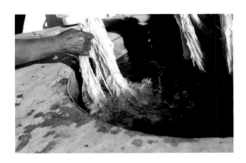

the first democratic election, between 25 and 40 percent of the population remains unemployed. While much has been done to improve living conditions, many people in the countryside especially remain desperately poor, and farmworkers are among the most vulnerable. Despite—or because of—record levels of economic growth, inequality is deepening. A prominent economist predicts that the gap between rich and poor will continue to grow for at least the next decade.[13]

Some argue for a special "fit" between Afrikaans and the South African landscape, an affinity between words like *vlei* and *vlakte*, *koppie* and *krans*[14] and the features they describe, "words that give life to the ways in which one senses and experiences much of what it is to be South African."[15] The music of Afrikaans farm names drifts through South African writing like a hymn that hopes to establish a bond with the land or strengthen a bond that is failing.

Heuningkloof, Rietvlei, Moedersgift, Eensgevonden, Kommando Drift.[16] These are the names, harking back to times of peace and war, that crop up in Karel Schoeman's reworking of the *plaasroman, Na die Geliefde Land* (1972).[17] In a future South Africa, after the "troubles" have turned the tables of power and privilege, a handful of Afrikaners who have trekked from the cities back into the countryside cling to a paltry version of their life and culture on impoverished farms.

"Verlatenfontein, Heuningneskloof, Brakspruit, Eensaamheid, . . . Erfdeel."[18] Another litany, with a similar emphasis on both the sweet and the bitter sides of a farming heritage. These names are spoken by the narrator of Antjie Krog's *A Change of Tongue* while driving through the southern Free State, trying to grasp the meaning of landscape in a transformed society. She goes on to tell a story about a Smithfield farmer and his laborers on the eve of the first democratic elections, imagining a world in which they have traded places, until the audacity of their vision strikes them all speechless.

Agaat's geography lesson has already been described. Milla is on the bedpan, humiliated and defeated; Agaat is pointing out places on the map with the end of a feather duster. In the middle of this torture, Agaat reels off a list of names, turning them into questions, items in an interrogation: "Hooikraal? Tygerhoek? Boschjesmansrug? Adderskop? Holgat? Van Rheenenshoogte . . . ?" (p. 403). The list, mocking Milla's predicament by alluding to the heights and hollows of her body, parodies the "fit" between Afrikaans and the landscape it names.[19]

At the very end of the 1980s, just months before the lifting of the ban on the ANC and other organizations, another farm name erupted into South African discourse: Vlakplaas. This charmless name, suggesting a flat and featureless place, identified the farm outside Pretoria where the assassins of the apartheid security police met to plan their actions, to relax between murders, to torture and kill suspects. The very name evokes a shallow grave, the sort of burial place from which a body might wash to accuse the living (as in *The Conservationist*).

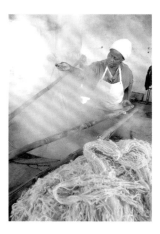

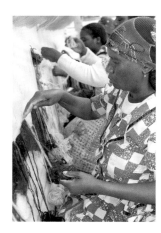

In the course of the 1990s, as more of the apartheid state's crimes were revealed before the Truth and Reconciliation Commission, it became known that the bodies of many murdered activists had been disposed of on farms. Their unmarked graves signified the very opposite of the usual farm burial: that the victim belonged nowhere and was nothing. As these remains were exhumed, scattered places with homely names—Elandskop, Boshoek, Goede Hoop—were drawn together into a map of personal sacrifice that extended beyond the well-known sites of massacres into the furthest corners of the countryside.

A small graveyard on a family farm is supposed to be a place of belonging. The body is still at home here, mingled with the soil that once sustained it and drawn into a cycle of regeneration. A farm burial anchors a lineage stretching back in time, measured in sweat and blood, and expresses a claim on the future. To be buried somewhere is to remain there, inalienably part of the scene.

However, some recent South African writing expresses a break in this comforting continuity with the soil. At the end of Krog's *A Change of Tongue*, the narrator buries her father. By the time of his death, circumstances have made it impossible for him to live on the land and his farm has been leased to someone else. Permission must be sought from the new tenant to use the farm graveyard, and the mourners arrive like thieves through a cut fence.

What is the symbolic freight of such a burial? The narrator asks her brother: "Do we really want to bury Pa in land that none of us farm any more? That we might sell soon? Would you like to be buried in somebody else's land?" His answer splits the metaphoric bond between farm and country by treating belonging as more important than owning: "If you want to look at it that way, you can just as well say that the whole country is somebody else's land. . . . We all want to be buried on the farm, even if it is no longer ours. We are of it."[20]

The earth itself seems to dispute this notion. When the father's grave is being readied, the gravediggers strike ironstone. It's as if the abandoned farm is reluctant to accept the body. A crypt must be hacked from the stone with hammers and chisels.

In *Agaat*, the passage from dust to dust is also disrupted, in this case by a manmade barrier: Milla's grave is lined with concrete. But her possession of the grave is challenged more strongly by a gesture of Agaat's. Before Milla dies, Agaat tries out the grave for size, laying claim even to that space before Milla occupies it.

What is being buried in these books is less a human being than a historical presumption. The mortal remains of an easy, inalienable right to the land are laid to rest.

City people accept that to die is to lose your place in the world. It is not usual for a city person to be buried at the bottom of the garden, between the pool filter and the tool shed. Rather, the city's dead are removed to their own suburbs, zoned by religious affiliation, it's true, but fairly democratic places nonetheless, tucked away

on the edge of town where the living do not have to keep tripping over them. A city cemetery is low-cost housing for the dead.

"Peri-urban" is a term with a peculiarly South African currency. You will find it in few English dictionaries—they generally go straight from "peritonitis" to "periwig." But it occurs even in the pocket editions of English-Afrikaans dictionaries, translated as *halfstedelik*. A "peri-urban area" is a *randgebied* or *randdorp*, an area or town on the outskirts, at the edge.

South Africans seem unusually attuned to these ill-defined, in-between zones where the city gives way to farm or countryside, not least because they used to serve as buffers or transitions between the white city and the black township. It is telling that apartheid planning sought to locate black people not just on the edges of the city but *beyond* the edges, on the far side of the outskirts, in the back of beyond.

William Kentridge has always been wary of the countryside. Commenting on the ethnographic films of "village life" he watched as a schoolboy, he remarked that "this vision of Africa seemed a complete fiction, far less convincing than the Tarzan films we were allowed to see at the end of the term. The Africans I knew and met did not live in mud huts guarding cattle, playing drums; they took buses, wore smart hats, lived in small rooms at the back of large houses, listened to the wireless."[21]

Kentridge is ambivalent too about urban and even suburban spaces. His modernist mansions and Art Deco avenues are jittery, crawling with unease. "Urbanity," the affable, self-confident demeanor of the citydweller, is no more than a mask.

For moments of calm in Kentridge's unsettled universe, we must look to the peri-urban area, the mining wasteland, the blasted veld marred by slimes dams and tailings. This is a tainted, worked-over middle ground, whose original nature—*fontein, vlei, kloof, krans*—has not been erased but spoiled. "Compared with drawing a mountain created over time by movements of the earth's surface," Kentridge writes, "there's something more direct about drawing a culvert or ditch that wasn't there a hundred years ago, the trace of some activity that has passed."[22] He treats this compromised, impure territory and its human wreckage with tenderness.

One hundred and twenty years after Johannesburg was proclaimed on a triangle of wasteland between three farms, the city continues to spread, ingesting veld and farmland as it goes. In these peripheral areas, far removed from the old CBD and its peri-urban clutter, a form of suburban countryside has evolved.

The housing developments here, and the lifestyles designed and marketed for them, try to capitalize on the advantages of country living (space, clean air, access to nature) and allay the fears associated with it (relative isolation, vulnerability to crime). The "country estate" is usually a walled suburb incorporating a *vlei* and its

birdlife or a patch of indigenous bushveld and a few established trees.[23] A taste for this kind of environment was primed by eco-sensitive gardeners in the older suburbs, where indigenous gardens have become popular over the last few years, with native trees, shrubs, and grasses displacing the exotics.

But it is the lucky property developer who is dealing with pristine veld. More often it is farmland, not heavily developed or cultivated but marked by prior use. Rather than trying to erase these traces, canny developers have begun to incorporate existing sheds, dams, and other farm-related structures with new features in a complementary style. These "farm estates" are secure residential complexes with an agricultural theme. Following Njabulo Ndebele, I could characterize the suburbanites destined to occupy these places as "leisure pastoralists."[24]

The farm estate is a new idyll. It is untroubled by physical labor; the happy residents are not expected to muck out the stables or plough on the halves. But the windows of the gym might offer a panorama of the working sectors of the estate, of fields, kraals, and barns, so that the sweat worked up on the treadmill bears a symbolic relationship to the soil.

Ideally, the residential component of a farm estate is hitched to the working one like a cart to a horse. The perfect host is a working dairy farm. A little herd of Friesians, crisply black and white against green pasture, would be an appealing element in the overall design. Cows are quite well behaved and easy to live with, as their long association with humans and their habitats attests. But pigs always spoil the atmosphere. As for chickens, a bantam or two scratching in the flowerbeds might be colorful, but a battery shed is an eyesore.

Developers are on the lookout for farms that are old enough to have grown quaint, with stone-walled barns, roughly plastered walls, and established orchards (picking fruit is a pleasant diversion). Obsolete equipment, a feature of any farmyard, carries the style through to the complex as a whole. An old tractor easily looks like a monument to mechanization.

On a farm estate, the residents rise early—when the cock crows, if they please. They keep gumboots at the door. The air outside is bracing, rich with the scent of hay and dew on freshly turned earth. The coffee shop is in the original farmhouse. While they're sipping their morning cappuccinos and glancing through the headlines, the milk cart rattles over the cobbles outside. The freeway is five minutes away and the rush hour has not even started.

1. Dan Cameron, Carolyn Christov-Bakargiev, and J. M. Coetzee, *William Kentridge* (London: Phaidon, 1999), p. 31.

2. The Witwatersrand, literally "ridge of white water," is a rocky, gold-bearing ridge stretching more than 125 miles through Gauteng Province. Smaller mining towns are spread out along the Rand, or the Reef, as it is also known, with Johannesburg at its center.

3. A *fontein* is a spring; *vlei* is a shallow pool or marsh. For a good account of the city's origins, see Irwin Manoim, "Joburg: The City without Water" (City of Johannesburg, accessed 23 February 2007), <http://www.joburgnews.co.za/heritage/without-water>.

4. J. M. Coetzee, *White Writing: On the Culture of Letters in South Africa* (Johannesburg: Radix, 1988), p. 81.

5. Marlene van Niekerk, *Agaat*, trans. Michiel Heyns (Cape Town: Tafelberg; Johannesburg: Jonathan Ball, 2006). All page references in the text are to this edition. The Afrikaans original appeared in 2004.

6. In South Africa, the term "coloured" is used to refer to people of mixed race.

7. This is also true of other representations, like the skeletal jottings in Milla's notebooks, which support two contrasting embodiments of the past for Milla and Agaat.

8. Michel de Certeau, *The Practice of Everyday Life* (Berkeley: University of California Press, 1988), p. 104.

9. Ibid., p. 105.

10. Pretoria, founded in 1855, was named after Voortrekker leader Andries Pretorius. Tshwane, the proposed new name, is of precolonial origin.

11. Johann Rossouw, "Alienation Much More Symbolic Than Material," *Sunday Times* (Johannesburg), March 4, 2007, p. 21.

12. The phrase occurs in the epigraph to the novel, which ironically quotes Betsie Verwoerd's foreword to a handbook on embroidery.

13. "Growth Fuels Inequality—Manuel," *Business Report*, April 23, 2007, p. 11. The prediction was made by Lumkile Mondi, chief economist of the Industrial Development Corporation.

14. *Vlakte* is flat land or open plain; a *koppie* is a small hill; a *krans* is a cliff or wall of rock.

15. Charles van Onselen, *The Seed Is Mine* (Cape Town: David Philip, 1996), p. vi.

16. These place-names translate literally as, respectively, Honey Gorge, Reed Lake, Mother's Gift, Once-Found, and Commando Ford (a "commando" being a unit of the Boer army during the South African War). Van Niekerk deals with the essential untranslatability of farm names (and features of the landscape generally) at several points in *Agaat*. "Translate Grootmoedersdrift. Try it. Granny's Ford. Granny's Passion? What does that say?" (p. 6). Elsewhere, the English equivalents of words like *rûens*, *droëland*, and *drif*—ridges, dry farmland, and crossing, respectively—are described as "prosaic" (p. 8).

17. Published in English translation as *Promised Land* (London: Julian Friedmann, 1978).

18. Antjie Krog, *A Change of Tongue* (Johannesburg: Random House, 2003), p. 27. These place-names translate literally as Desolate Springs, Honey-Nest Gorge, Brackish Stream, Loneliness, and Inheritance.

19. The double entendres on landscape and body are in terms such as *rug* (ridge and back), *kop* (hill and head), and *gat* (hole and backside).

20. Krog, *A Change of Tongue*, p. 360.

21. Cameron et al., *William Kentridge*, p. 108.

22. Ibid., p. 22.

23. The Blue Bird Private Estate, to take just one recent example, is advertised as a subdivided farm consisting of seven "portions" of "beautiful indigenous bush" and including "game and stables." "Prestige Property Showcase February/March 2007," Pam Golding Properties advertising supplement.

24. In the early post-apartheid years, when previously segregated facilities were first opened to all South Africans, Njabulo Ndebele wrote about the novel experience of visiting a game reserve and the ethical questions this presented for a new class of "leisure colonialists." Njabulo Ndebele, "Game Lodges and Leisure Colonialists," in *blank____: Architecture, apartheid and after*, ed. Hilton Judin and Ivan Vladislavić (Rotterdam: NAi Publishers, 1998), pp. 119–23.

About the Artist

William Kentridge was born in Johannesburg, South Africa, in 1955, seven years after the 1948 elections that instituted apartheid (Afrikaans for "separateness") as a government-sponsored regime that imposed rigorous restrictions on nonwhite citizens, from mandating the types of employment available to them and controlling areas of tenancy to disallowing their right to vote. The son of two prominent lawyers committed to representing those the apartheid system oppressed, Kentridge came of age, and sought to come to terms with, the fragmented and fractured society of Johannesburg, a city whose elite center was surrounded by shantytowns full of marginalized black, Indian, and other nonwhite populations. As a student at the University of Witwatersrand in the 1970s, Kentridge focused on politics and African Studies, but in the years following he would find theater and art better suited to grappling with his country's tension and plight. He began to act, write, and design sets for the racially integrated Junction Avenue Theatre Company, and he introduced fine art into his repertoire in 1976–78 while studying at the Johannesburg Art Foundation. In 1978, Kentridge began experimenting with film and also had his first solo show at the Market Gallery in Johannesburg.

While studying theater and mime in Paris in 1981–82, Kentridge also exhibited in numerous group shows in South Africa with drawings that evoked European influences such as Max Beckmann and Francisco Goya. His short film *Howl at the Moon* earned a Red Ribbon Award at New York's American Film Festival in 1982, and he garnered a Blue Ribbon in 1985 with another short. Following his first group show in New York in 1986 and first solo show London in 1987, Kentridge made *Johannesburg, 2nd Greatest City After Paris* in 1989, the first in a series of animated films deriving from his nine *Drawings for Projection* that tell the epic tale of Kentridge's opposing and semi-autobiographical characters—the avaricious businessman Soho Eckstein and the romantic and somewhat lost soul Felix Teitlebaum.

In 1993 Kentridge's films were screened at the Venice Biennale, the Museum of Modern Art in New York, and the Centre Georges Pompidou in Paris. During this period, negotiations within the government started to dismantle South Africa's apartheid system, and in 1994 a democratic election accepted votes from across the populace in an effort to unify the country. Yet the ideals of reintegration in areas such as Johannesburg were met with the volatile reality of rich and poor populations sharing metropolitan spaces. The city hosted the global art community in 1995 and 1997 for two Johannesburg Biennials, both of which included works by Kentridge. He soon became a leading voice in contemporary art through practice that deals expressly with the plight of South Africa but also resonates with strife-stricken communities and cultures throughout the world. In 1997 his films were included in Documenta x in Kassel, Germany, and in 1998 in New York the Drawing Center hosted a show of his

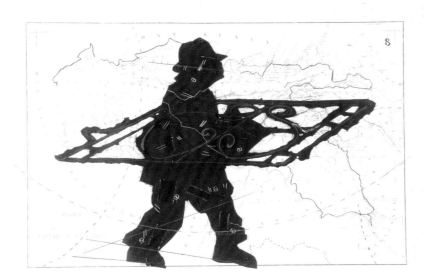

William Kentridge, enlarged photograph of *Puppet Drawing* with artist's marks, made in preparation for the tapestry *Porter Series: Expédition du jeune Cyrus et Retraite des Dix-mille (with Wrought Iron)*, 2006–7 (see p. 115). Courtesy of the artist

works on paper, the Museum of Modern Art held *Project 68: William Kentridge*, and he was short-listed for the prestigious Hugo Boss Prize at the Guggenheim Museum Soho.

By the early twenty-first century, Kentridge's global reputation as one of the most fascinating and innovative artists spurred the Museum of Contemporary Art, Chicago, and the New Museum of Contemporary Art, New York, to co-organize a survey exhibition that also traveled to Washington, D.C., Houston, Los Angeles, and Cape Town. In 2001, Creative Time aired his film *Shadow Procession* on the NBC Astrovision Panasonic screen in Times Square. Along with his art projects, Kentridge has also remained involved in theater, and his puppet-based play *Confessions of Zeno*—one of several collaborations with the Handspring Puppet Company in Johannesburg—was presented at Documenta11 in 2002, as was his film *Zeno Writing*. In 2004–5, a major retrospective of Kentridge's work was shown in Turin, Düsseldorf, Sydney, Montreal, and Johannesburg. His recent staging of Mozart's opera *The Magic Flute* played to audiences in Brussels, Tel Aviv, Naples, New York, and Johannesburg. Kentridge continues to live and work in Johannesburg, and he is represented internationally by Marian Goodman Gallery in New York, Lia Rumma Gallery in Naples and Milan, and Goodman Gallery in Johannesburg.

—ERICA F. BATTLE

The Stephens Tapestry Studio

Opened in 1963 as a branch of a carpet and curtain business in Swaziland, the Stephens Tapestry Studio moved in 1965 to Diepsloot, a suburb of Johannesburg in South Africa, where it established itself as an independent workshop focused on raising awareness of weaving as an art. The studio has collaborated with a wide array of artists from South Africa and Europe—including Gillian Ayres, Gerard Sekoto, Eduardo Villa, and Tito Zongu—allowing them to experiment with and realize works in the tapestry medium. Included in many public collections throughout the world, the tapestries produced by the studio have also been exhibited at numerous museums and galleries—most notably at the Goodman Gallery in Johannesburg since 1970.

Stephens and her team of weavers create tapestries that range from wall-sized to monumental. Production begins in a cottage in Swaziland, where mohair shorn from goats and purchased in bulk is carded and spun, a process requiring at least ten to fifteen women for each tapestry. Four dyers then achieve a variety of subtle tones working from the three primary colors. The weft is dyed in vats over a wood fire and hung to dry in the sun. The rest of the process takes place at the Diepsloot studio, where Stephens herself participates in the crucial stage of translating the artist's work by hand into a large-scale cartoon. The cartoon is a full-sized map for the weavers to follow with exacting detail, and it includes annotations specifying colors as well as outlining the patterns, forms, and characteristics that comprise the artwork's imagery. Using the French Gobelin high-warp technique, the weavers work on vertical looms, and the weft is woven in a horizontal motion. The cartoon is placed behind the loom face as a guide to the weavers as they create the tapestry from the bottom up.

Stephens recognizes that the artist involved in the collaboration can be one whose sensibilities resonate exclusively with the decorative aspect of tapestry, or one whose work is also considered political or controversial. While the art of tapestry is based in precision, it also possesses plasticity that can capture many different artistic expressions and can allow for successful collaborations such as the series produced with William Kentridge. Since 2001 Stephens and the weavers in the studio have created nearly a hundred tapestries from the artist's series of seventeen *Puppet Drawings*. For Stephens, the combination of a strong artistic vision and meticulous execution is what produces a successful tapestry, and it can be judged only when the tapestry is released from the loom and hung for the first time, becoming a work of art in its own right that possesses reverberations of the touch of all who participated in the process of its making.

—ERICA F. BATTLE

Marguerite Stephens and weavers at the Diepsloot studio outside Johannesburg. Photograph by John Hodgkiss, courtesy of the William Kentridge Studio

Head Weavers: Margaret Zulu, June Xaba
Weavers: Zanele Zulu, Virginia Mzimba, Treasure Zulu, Phuti Zulu, Rhoda Tibha, Daphne Lukhele, Mavis Manzini, Tracy Ncube, Philele Shongwe, Gladis Mzimba
Spinners: Christine Vilakazi, Ida Shongwe, Sipewe Mhonza, Dudu Dlamini
Dyers: Sylvia Mantanga, Hlobsile Fakude, Dunsile Shongwe, Selvia Dlamini

Exhibition Checklist

WORKS ON PAPER

Procession on Anatomy of Vertebrates
2000
Charcoal on book pages
8½ x 66¹⁵⁄₁₆ inches (21.6 x 170 cm)
Collection of Brenda Potter and Michael Sandler,
Beverly Hills, California
Plate 1 (pp. 22–23)

Portage
2000
Chine collé of figures from black Canson paper on pages from
Le Nouveau Larousse Illustre Encyclopaedia (c. 1906), on Velin
Arches Crème paper, folded as a leperello
Image 10¹³⁄₁₆ x 166½ inches (27.5 x 423 cm); portfolio (folded)
11⁷⁄₁₆ x 10¹⁄₁₆ x ¾ inches (29 x 25.5 x 2 cm)
Collection of the artist
Plate 2 (pp. 24–25)

Untitled Study for Tapestry (Office Love)
2001
Chine collé and collage
28¾ x 37¹³⁄₁₆ inches (73 x 96 cm)
Johannesburg Stock Exchange, South Africa
Plate 5 (p. 28)

Puppet Drawing
2000
Collage, construction paper, tape, chalk, and pins on atlas page
13¼ x 18¾ inches (33.7 x 47.6 cm)
Private collection
Plate 6 (p. 29)

Puppet Drawing
2000
Collage, construction paper, tape, chalk, and pins on atlas page
13¼ x 18¾ inches (33.7 x 47.6 cm)
Private collection
Plate 7 (p. 30)

Puppet Drawing
2000
Collage, construction paper, tape, chalk, and pins on atlas page
13¼ x 18¾ inches (33.7 x 47.6 cm)
Collection of Bette Ziegler, New York
Plate 8 (p. 31)

Puppet Drawing
2000
Collage, construction paper, tape, chalk, pins on atlas page
18¾ x 13¼ inches (47.6 x 33.7 cm)
Marc and Livia Straus Family Collection
Plate 9 (p. 32)

Puppet Drawing
2000
Collage, construction paper, tape, chalk, pins on atlas page
18½ x 13⅜ inches (47 x 34 cm)
Collection of Edwin C. Cohen, New York
Plate 10 (p. 33)

Puppet Drawing
2000
Collage, construction paper, tape, chalk, pins on atlas page
18½ x 13⅜ inches (47 x 34 cm)
Collection of Melva Bucksbaum and Raymond Learsy,
Connecticut
Plate 11 (p. 34)

Puppet Drawing
2000
Collage, construction paper, tape, chalk, and pins on atlas page
13⅜ x 18½ inches (34 x 47 cm)
Collection of Brenda Potter and Michael Sandler,
Beverly Hills, California
Plate 12 (p. 35)

Puppet Drawing
2000
Collage, construction paper, tape, chalk, and pins on atlas page
13¼ x 18¾ inches (33.7 x 47.6 cm)
Private collection
Plate 13 (p. 36)

Puppet Drawing
2000
Collage, construction paper, tape, chalk, and pins on atlas page
13¼ x 18¾ inches (33.7 x 47.6 cm)
Private collection
Plate 14 (p. 37)

Puppet Drawing
2000
Collage, construction paper, tape, chalk, and pins on atlas page
13¼ x 18¾ inches (33.7 x 47.6 cm)
Collection of Dr. and Mrs. Jerry Sherman, Baltimore
Plate 15 (p. 38)

Zeno at 4 a.m.
2001
Series of nine etchings and aquatints
Publisher: David Krut Fine Art, New York and Johannesburg
Printer: Artists' Proof Studio, Johannesburg
Edition: 40
Plates 9¾ x 7¹³⁄₁₆ inches (24.7 x 19.8 cm) each; sheets 14 x
11⅝ inches (35.6 x 29.5 cm) each
The Museum of Modern Art, New York, Mary Ellen
Meehan Fund, 2001
Plates 16a–i (pp. 39–41)

SCULPTURES

Bridge
2001
Bronze with books
23⅝ x 36¾ x 7½ inches (60 x 93.2 x 19 cm)
Collection of the artist
Plate 3 (p. 26)

Promenade II
2002
Bronze
Tallest figure 14¾ x 10⁵⁄₁₆ x 6¾ inches (37.5 x 26.2 x 17 cm)
Collection of the artist
Plate 4 (p. 27)

TAPESTRIES

Office Love, 2001
Tapestry weave with embroidery. Warp: polyester. Weft and embroidery: mohair, acrylic, and polyester
135⁷⁄₁₆ x 179½ inches (344 x 455.9 cm)
Woven by the Stephens Tapestry Studio
1st artist's proof (of 2)
Philadelphia Museum of Art. Purchased with funds contributed by the members of the Committee on Modern and Contemporary Art, 2006-137-1
Plate 17 (p. 65)

Porter Series: Germanie et des pays adjacents du sud et de l'est (Pylon Lady), 2006
Tapestry weave with embroidery. Warp: polyester. Weft and embroidery: mohair, acrylic, and polyester
102¾ x 134½ inches (261 x 341.6 cm)
Woven by the Stephens Tapestry Studio
Edition: 1/5
Collection of Massimo d'Alessandro, Rome
Plate 18 (p. 67)

Porter Series: France divisée en ses 32 provinces (Shower Man), 2006
Tapestry weave with embroidery. Warp: polyester. Weft and embroidery: mohair, acrylic, and polyester
97⅝ x 134½ inches (248 x 341.6 cm)
Woven by the Stephens Tapestry Studio
Edition: 1/5
Collection of Leo and Pearl-Lynn Katz, Bogotá, Colombia
Plate 19 (p. 69)

Porter Series: Egypte, 2006
Tapestry weave with embroidery. Warp: polyester. Weft and embroidery: mohair, acrylic, and polyester
99½ x 134 inches (252.7 x 340.4 cm)
Woven by the Stephens Tapestry Studio
1st artist's proof (of 2)
Courtesy of Lia Rumma Gallery, Milan
Plate 20 (p. 71)

Porter Series: Amérique septentrionale (Bundle on Back), 2007
Tapestry weave with embroidery. Warp: polyester. Weft and embroidery: mohair, acrylic, silk, and polyester
122⁷⁄₁₆ x 90¹⁵⁄₁₆ inches (311 x 231 cm)
Woven by the Stephens Tapestry Studio
Edition: 1/5
Collection of Isabel and Agustín Coppel, Mexico City
Plate 21 (p. 73)

Porter Series: Norwège, Suède et Danemark (Porter with Chairs), 2005
Tapestry weave with embroidery. Warp: polyester. Weft and embroidery: mohair, acrylic, and polyester
108 x 78 inches (274.3 x 198.1 cm)
Woven by the Stephens Tapestry Studio
1st artist's proof (of 2)
Private collection
Plate 22 (p. 75)

Porter Series: Russie d'Europe (Man with Bed on Back), 2007
Tapestry weave with embroidery. Warp: polyester. Weft and embroidery: mohair, acrylic, and polyester
123 x 90¾ inches (312.4 x 230.5 cm)
Woven by the Stephens Tapestry Studio
1st artist's proof (of 2)
Private collection
Plate 23 (p. 77)

Porter Series: Espagne et Portugal (Porter with Bicycle), 2004
Tapestry weave with embroidery. Warp: polyester. Weft and embroidery: mohair, acrylic, and polyester
98¾ x 130½ inches (250.8 x 331.5 cm)
Woven by the Stephens Tapestry Studio
1st artist's proof (of 2)
Private collection
Plate 24 (p. 79)

Porter Series: Asie Mineure (Tree Man), 2006
Tapestry weave with embroidery. Warp: polyester. Weft and embroidery: mohair, acrylic, and polyester
97⅝ x 135⅛ inches (248 x 343.2 cm)
Woven by the Stephens Tapestry Studio
Edition: 1/5
D'Amato Collection, Naples
Plate 25 (p. 81)

Porter Series: Espagne ancienne (Porter with Dividers), 2005
Tapestry weave with embroidery. Warp: polyester. Weft and embroidery: mohair, acrylic, and polyester
98¾ x 132½ inches (250.8 x 336.6 cm)
Woven by the Stephens Tapestry Studio
1st artist's proof (of 2)
Courtesy of Lia Rumma Gallery, Milan
Plate 26 (p. 83)

Porter Series: Géographie des Hebreux ou Tableau de la dispersion des Enfants de Noë, 2005
Tapestry weave with embroidery. Warp: polyester. Weft and embroidery: mohair, acrylic, and polyester
100½ x 137⅞ inches (255.3 x 350.2 cm)
Woven by the Stephens Tapestry Studio
Edition: 3/3
Collection of Anne and William Palmer, New York
Plate 27 (p. 85)

Illustrated Checklist
of Tapestries by
William Kentridge,
2001–7

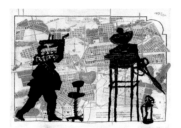

Office Love, 2001–5
Tapestry weave with embroidery. Warp: polyester. Weft and
embroidery: mohair, acrylic, and polyester
Woven by the Stephens Tapestry Studio
Edition: 3 + 2 artist's proofs
Collections: Johannesburg Stock Exchange; Philadelphia Museum of
Art; Silvio Sansone, Naples; private collection, Australia; and others
Plate 17 (p. 65)

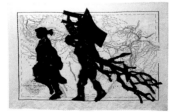

Porter Series: Conquêtes d'Alexander, 2001–3
Tapestry weave with embroidery. Warp: polyester. Weft and
embroidery: mohair, acrylic, and polyester
Woven by the Stephens Tapestry Studio
Edition: 3 + 2 artist's proofs
Collections: Giuseppe Calabresi, Rome; Lia Rumma, Naples-Milan;
Gemma De Angelis Testa, Milan; private collection, Australia;
private collection, Venice
Not in exhibition

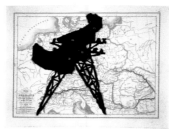

*Porter Series: Germanie et des pays adjacents du sud et de l'est
(Pylon Lady)*, 2001–6
Tapestry weave with embroidery. Warp: polyester. Weft and
embroidery: mohair, acrylic, and polyester
Woven by the Stephens Tapestry Studio
Edition: 5 + 2 artist's proofs
Collections: Alessandra and Paolo Barillari, Italy; Massimo d'Alessandro,
Rome; Diego della Valle, Italy; Lia Rumma, Naples-Milan; and others
Plate 18 (p. 67)

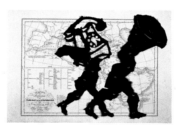

*Porter Series: Géographie des Hebreux ou Tableau de la dispersion des
Enfants de Noë*, 2001–5
Tapestry weave with embroidery. Warp: polyester. Weft and
embroidery: mohair, acrylic, and polyester
Woven by the Stephens Tapestry Studio
Edition: 3 + 2 artist's proofs
Collections: Claude Berri, Paris; Anne and William Palmer, New York;
Lia Rumma, Naples-Milan; private collection, Milan; and others
Plate 27 (p. 85)

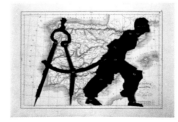

Porter Series: Espagne ancienne (Porter with Dividers), 2001–5
Tapestry weave with embroidery. Warp: polyester. Weft and
embroidery: mohair, acrylic, and polyester
Woven by the Stephens Tapestry Studio
Edition: 3 + 2 artist's proofs
Collections: Ernesto Esposito, Naples; Lia Rumma, Naples-Milan;
private collection, London; private collection, Switzerland; and others
Plate 26 (p. 83)

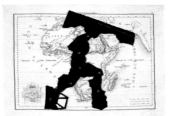

Porter Series: Afrique, 2001
Tapestry weave with embroidery. Warp: polyester. Weft and
embroidery: mohair, acrylic, and polyester
Woven by the Stephens Tapestry Studio
Edition: 3 + 2 artist's proofs
Collections: BOE Private Bank, South Africa; Greatford Estates,
London; Mario Testino, London; private collection, South Africa;
and others
Not in exhibition

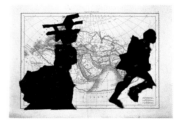

Porter Series: Egypte, 2002–6
Tapestry weave with embroidery. Warp: polyester. Weft and
embroidery: mohair, acrylic, and polyester
Woven by the Stephens Tapestry Studio
Edition: 3 + 2 artist's proofs
Collections: Luigi Giordano, Oleggio, Italy; Lia Rumma, Naples-Milan;
Juanita Sabbadini, Milan; private collection, Bologna; and others
Plate 20 (p. 71)

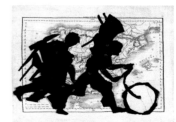

Porter Series: Espagne et Portugal (Porter with Bicycle), 2003–4
Tapestry weave with embroidery. Warp: polyester. Weft and
embroidery: mohair, acrylic, and polyester
Woven by the Stephens Tapestry Studio
Edition: 3 + 2 artist's proofs
Collections: Giancarlo Danieli, Vicenza, Italy; Lia Rumma, Naples-
Milan; Tokara Wine Estate, South Africa; private collection, Turin;
and others
Plate 24 (p. 79)

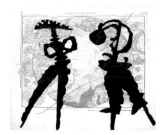

Porter Series: Nord-Polar-Karte, 2003–5
Tapestry weave with embroidery. Warp: polyester. Weft and embroidery: mohair, acrylic, and polyester
Woven by the Stephens Tapestry Studio
Edition: 3 + 2 artist's proofs
Collections: Silvio Sansone, Salerno, Italy; South African Reserve Bank, Pretoria, South Africa; private collection, Milan; private collection, Switzerland; and others
Not in exhibition

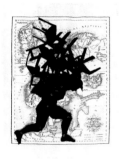

Porter Series: Norwège, Suède et Danemark (Porter with Chairs), 2004–5
Tapestry weave with embroidery. Warp: polyester. Weft and embroidery: mohair, acrylic, and polyester
Woven by the Stephens Tapestry Studio
Edition: 3 + 2 artist's proofs
Collections: CAP Art Collection, Ireland; private collection, Milan; private collection, Switzerland; and others
Plate 22 (p. 75)

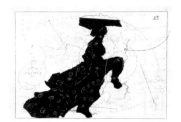

Porter Series: France divisée en ses 86 départements (Dancing Lady), 2006–7
Tapestry weave with embroidery. Warp: polyester. Weft and embroidery: mohair, acrylic, and polyester
Woven by the Stephens Tapestry Studio
Edition: 5 + 2 artist's proofs
Collections: Isabel and Agustín Coppel, Mexico City; Nicoletta Fiorucci, Rome; and others
Not in exhibition

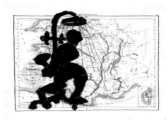

Porter Series: France divisée en ses 32 provinces (Shower Man), 2006
Tapestry weave with embroidery. Warp: polyester. Weft and embroidery: mohair, acrylic, and polyester
Woven by the Stephens Tapestry Studio
Edition: 5 + 2 artist's proofs
Collections: Alessandra and Paolo Barillari, Italy; Bernier-Eliades Gallery, Athens; Gandar Collection, Switzerland; Leo and Pearl-Lynn Katz, Bogotá, Colombia; and others
Plate 19 (p. 69)

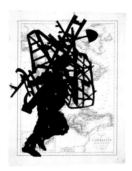

Porter Series: Amérique septentrionale (Bundle on Back), 2006–7
Tapestry weave with embroidery. Warp: polyester. Weft and embroidery: mohair, acrylic, silk, and polyester
Woven by the Stephens Tapestry Studio
Edition: 5 + 2 artist's proofs
Collections: Isabel and Agustín Coppel; and others
Plate 21 (p. 73)

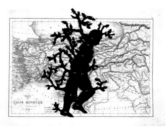

Porter Series: Asie Mineure (Tree Man), 2006
Tapestry weave with embroidery. Warp: polyester. Weft and embroidery: mohair, acrylic, and polyester
Woven by the Stephens Tapestry Studio
Edition: 5 + 2 artist's proofs
Collections: D'Amato Collection, Naples; Geomer Collection; private collection, Rome; and others
Plate 25 (p. 81)

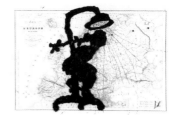

Porter Series: Europe divisée en les différent Etats (Shower Woman), 2006–7
Tapestry weave with embroidery. Warp: polyester. Weft and embroidery: mohair, acrylic, and polyester
Woven by the Stephens Tapestry Studio
Edition: 5 + 2 artist's proofs
Collections: Alessandra Almgren, New York; Guastalla Foundation, Rome; private collection, South Africa; and others
Not in exhibition

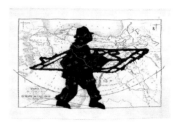

Porter Series: Expédition du jeune Cyrus et Retraite des Dix-mille (with Wrought Iron), 2006–7
Tapestry weave with embroidery. Warp: polyester. Weft and embroidery: mohair, acrylic, and polyester
Woven by the Stephens Tapestry Studio
Edition: 5 + 2 artist's proofs
Collections: Lia Rumma, Naples-Milan; and others
Not in exhibition

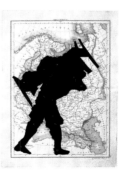

Porter Series: Russie d'Europe (Man with Bed on Back), 2007
Tapestry weave with embroidery. Warp: polyester. Weft and embroidery: mohair, acrylic, and polyester
Woven by the Stephens Tapestry Studio
Edition: 3 + 2 artist's proofs
Collections: Blake Byrne, Los Angeles; Giovanni Cornaro, Switzerland; private collection, Milan; and others
Plate 23 (p. 77)